FAULTLINES

FAULT LINES

LIFE AND LANDSCAPE IN SASKATCHEWAN'S OIL ECONOMY
PHOTOGRAPHS BY VALERIE ZINK TEXT BY EMILY EATON

UMP
University of Manitoba Press

University of Manitoba Press
Winnipeg, Manitoba
Canada R3T 2M5
uofmpress.ca

Printed in Canada

20 19 18 17 16 1 2 3 4 5

Cover image: Valerie Zink
Cover and interior design: Jess Koroscil
Map design: Weldon Hiebert

Library and Archives Canada Cataloguing in Publication

Zink, Valerie, 1981–, photographer
Fault lines : life and landscape in Saskatchewan's oil
economy / Valerie Zink, photographer ; Emily Eaton, author.

Includes bibliographical references.
Issued in print and electronic formats.
ISBN 978-0-88755-783-5 (pbk.)
ISBN 978-0-88755-516-9 (pdf)
ISBN 978-0-88755-514-5 (epub)

1. Petroleum industry and trade—Saskatchewan—Pictorialworks. 2. Petroleum industry and trade—Saskatchewan—Anecdotes. 3. Petroleum industry and trade—Saskatchewan—Employees—Social conditions—Pictorial works. 4. Petroleum industry and trade—Saskatchewan—Employees—Social conditions—Anecdotes. 5. Rural conditions—Saskatchewan—Pictorial works. 6. Rural development—Saskatchewan—Pictorial works. 7. Small cities—Saskatchewan—Pictorial works. 8. Saskatchewan—Pictorial works. I. Eaton, Emily, 1980–, author II. Title.

HD9574.C33S27 2016 338.2'7282097124 C2016-903124-1
 C2016-903125-X

The University of Manitoba Press gratefully acknowledges the financial support for its publication program provided by the Government of Canada through the Canada Book Fund, the Canada Council for the Arts, the Manitoba Department of Culture, Heritage, Tourism, the Manitoba Arts Council, and the Manitoba Book Publishing Tax Credit.

FSC
www.fsc.org
MIX
Paper from
responsible sources
FSC® C016245

To those who shared with us their stories,
their insights, themselves.

In gratefulness and love.

CONTENTS

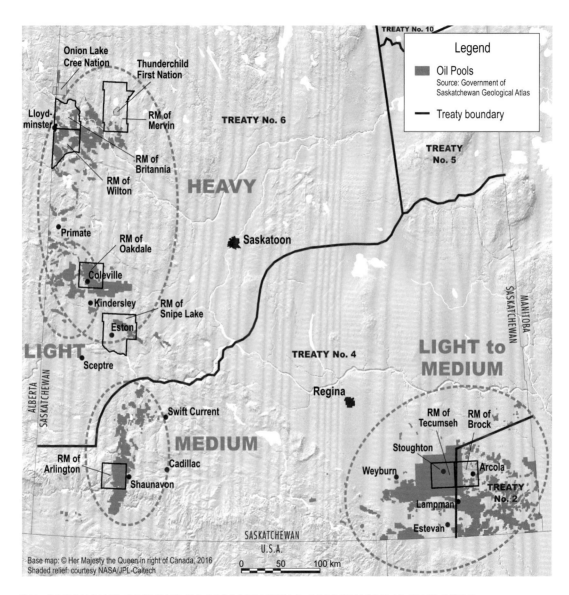

OIL-PRODUCING REGIONS OF SASKATCHEWAN REFERENCED IN THIS BOOK.

A NOTE ON THE PHOTOGRAPHS

As wood-crib grain elevators are torn down, pumpjacks are taking their place as the new fixture of the prairie landscape. Amid the ravages of rural decline, promises of prosperity during the recent oil boom breathed new life into old constructs of the Last Best West, spurring a wave of migration and minting millionaires in towns with skyrocketing rents and overstressed infrastructure. From the sea-can motel on the outskirts of Estevan to seismic testing sites on Thunderchild First Nation's Sundance grounds, this series of seventy-seven images captured during the height of the boom considers the ways in which the oil economy is remaking the spatial and cultural landscape of rural Saskatchewan. More than a lament for a pastoral plains, these images testify to a moment of transition and urge viewers to consider the complex consequences of rural communities' engagement with the oil economy.

— Valerie Zink

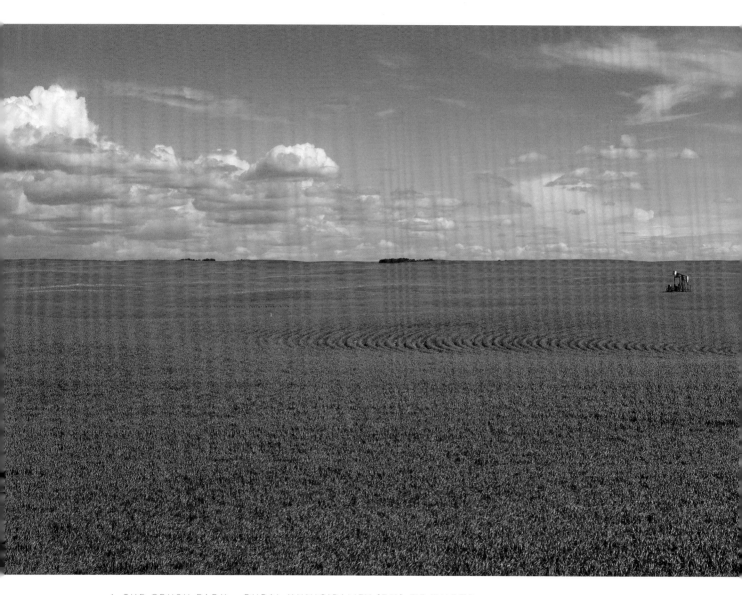

1. THE CRUSH FARM - RURAL MUNICIPALITY (RM) OF WILTON

INTRODUCTION

The boom-bust cycle of the oil economy is not new to Saskatchewan. Oil-producing communities have weathered periods of growth and decline since the 1950s when the industry began to spread across the province. But there is little doubt that the recent boom in unconventional oil production starting in the mid-2000s and ending with the collapse in oil prices in the fall of 2014 has reshaped rural lives and landscapes. Due to a host of forces that have consolidated farms into fewer, larger, and more capital-intensive operations, Saskatchewan's rural areas are in a moment of transition. While many small towns are suffering from depopulation and decline, others have benefitted from the recent oil boom. Only months before the sudden decline in international oil prices, these towns were characterized by new housing developments that stretched across the prairie, restaurants and bars that were always hiring, and transnational hotel chains that were opening new franchises. Campgrounds had no vacancy from May to September, grocery stores were popping up to serve new communities of immigrants, and younger generations were returning home to their communities where they found work in the oil industry or in jobs that serviced the industry and its workforce. In booming oil regions, oil leases—and in rarer cases, mineral rights—were adding stable revenues to family farms and transforming relationships with the land.

The results of this engagement with the industry have been celebrated in oil-producing areas; people proudly describe the rewards of the hard work associated with their outdoor jobs and how their communities have been invigorated by growth. In place of the abandoned houses and shuttered shops found in many small towns in Saskatchewan, housing developments sprang up, with new trucks and boats parked in driveways. Yet, during the boom, people in oil-producing areas also lived amid flare stacks that made them ill, had trouble finding housing due to vacancy rates that were among the lowest in the country, suffered through family breakdown because of long working hours and time spent away from home, and were faced with spills and leaks that contaminated their landscapes. While communities were largely dealing with these impacts quietly for fear of chasing away the industry upon which they saw themselves as dependent, some people were voicing their frustrations through surface rights organizations, through protest, and in private conversations with neighbours and community organizations.

2. FOAL - RM OF MERVIN

4. ELAINE AND TERRY - RM OF WILTON

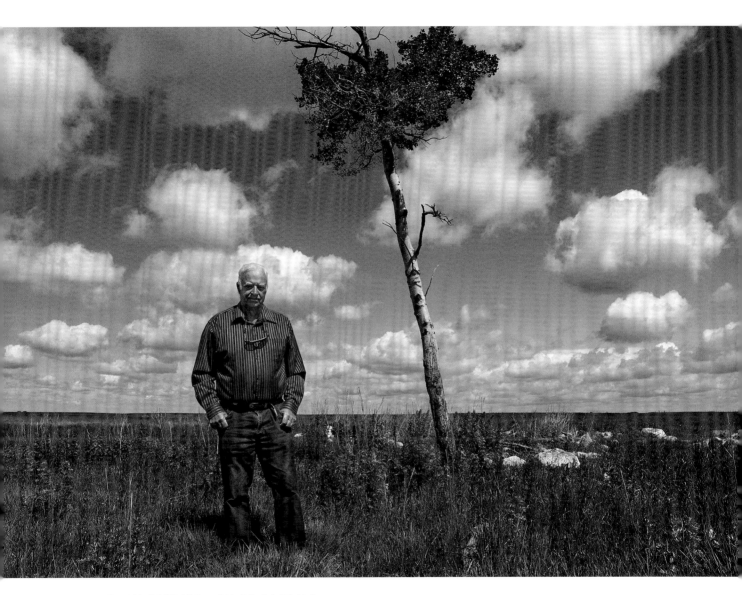

5. BILL'S PASTURE - RM OF OAKDALE

6. FARMSTEAD - RM OF SNIPE LAKE

This book explores the contradictory nature of the recent oil boom in Saskatchewan and examines how individuals and communities living amid oil struggled through a mix of engagement, celebration, ambivalence, and resistance to oil economies. The writing in this book is based on more than seventy interviews I conducted on the impacts, both positive and negative, of the booming Saskatchewan oil economy, as part of a Social Sciences and Humanities Research Council grant titled "What Sustains Saskatchewan's Oil Economy?" Interviews were conducted between 2011 and 2015, at the height of the boom, with a wide range of people including oil workers, regulators, environmental consultants, landowning farmers and ranchers, community pasture staff from the Prairie Farm Rehabilitation Administration, Indigenous land defenders, municipal politicians, temporary foreign workers, and social service providers. In the summer of 2014, I travelled with photographer Valerie Zink to booming oil towns across the province. This book also draws from observations and conversations that I have had while participating in events (such as surface rights meetings) and everyday life in Saskatchewan's major oil-producing regions while staying in campgrounds and visiting restaurants, bars, and other venues. I have identified interviewees by their names where permitted, but many people I spoke with preferred to remain unidentified.

7. CULTIVATING - SWIFT CURRENT

THE PAST, PRESENT, AND FUTURE OF OIL IN SASKATCHEWAN

Oil is only one of the natural resources that fuel Saskatchewan's export-led economy. Long a peripheral province in the confederation, Saskatchewan's rural areas were largely cleared of Indigenous peoples and settled as agricultural communities producing bulk commodities for international markets. In the mid-1900s rural agricultural areas in the south became host to oil and potash extraction, while uranium mining pushed into the province's north. Rural residents of oil-producing communities have lived through the ups and downs of the industry since the early 1950s when commercial production of oil began to flourish. Moreover, many see oil as fundamental to their futures—futures that will include the inevitable booms and busts inherent in resource-extractive economies. Oil is therefore fundamental to the history, present, and future of many regions in Saskatchewan, especially given the latest and largest oil boom that began in the mid-2000s and ended in 2014. In fact, a narrative I often heard from those working in the field views oil as the foundation of modern life and essential

to notions of freedom. For many of the people I spoke with, a future without oil amounts to "turning back the clock"—regressing to a period without leisure time, travel, or mechanized farm production. And to the extent that alternative employment and economies scarcely exist, oil is synonymous with reality itself. In many communities where oil has been a long-standing fixture of life, criticisms of fossil fuels and the industry are understood as threats to the present and future of life and livelihood.

Commercial production of oil in Saskatchewan began in 1945 in the heavy oil fields of Lloydminster, but small-scale exploration and oil refining date back to the early 1900s. An early period of unsuccessful exploration dominated by "small, independent, speculative operators, [and] wildcatters who relied upon modest local financing"[1] gave way to large exploration initiatives dominated by international companies like Standard Oil by the late 1940s. An exploration boom ensued, and by the early 1950s the industry had expanded into

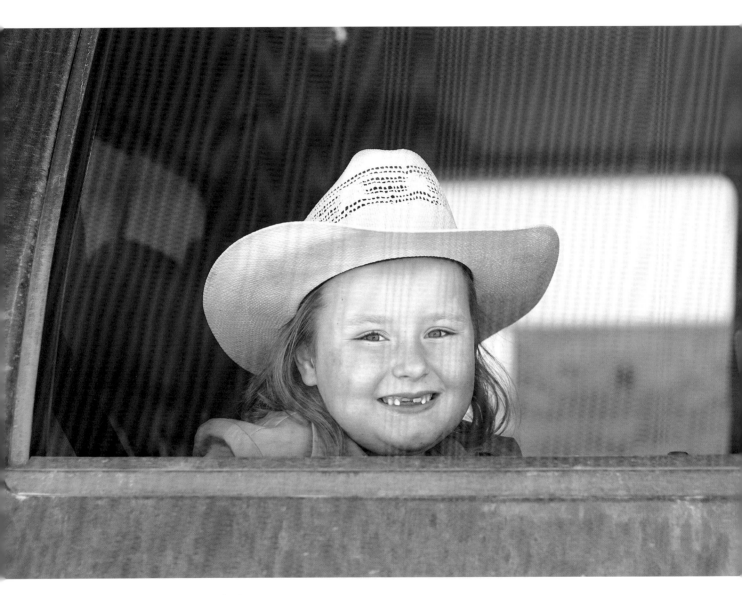

8. ALEXIS - ARCOLA

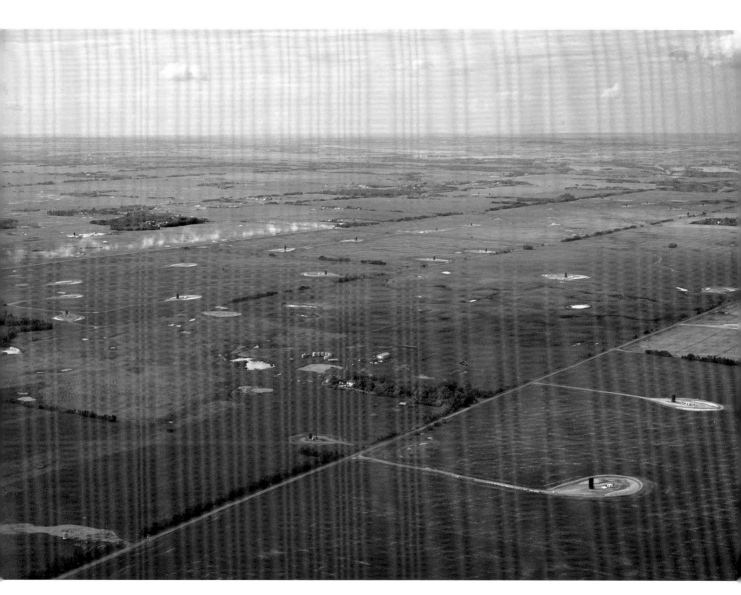

9. OIL LEASES - RM OF BRITANNIA

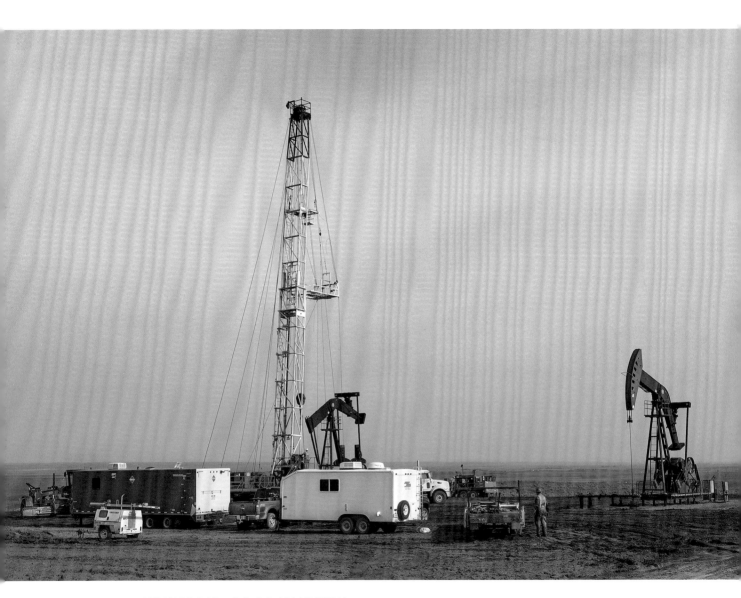

10. SERVICE RIG · RM OF ARLINGTON

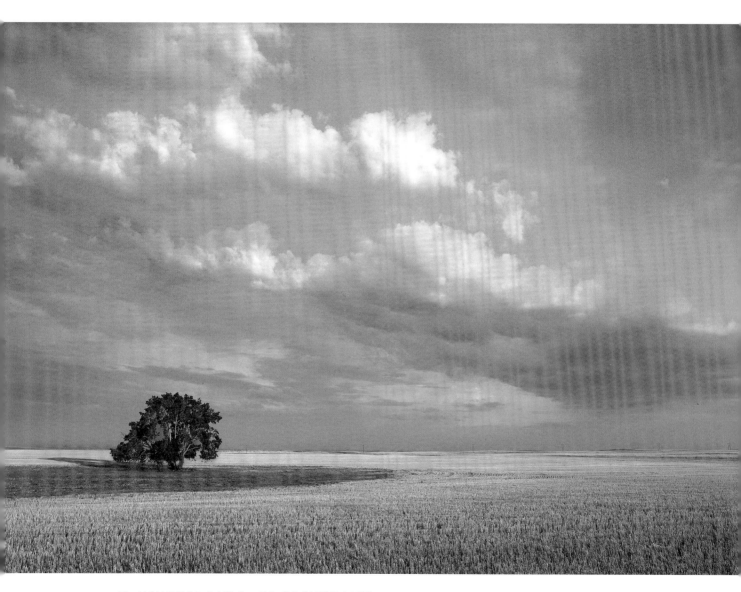

12. MANITOBA MAPLE - RM OF SNIPE LAKE

communities in the province's southeast, particularly around Weyburn and Estevan; the west central region surrounding Kindersley; and the southwest, including areas around Swift Current and Shaunavon. But unlike that of its neighbouring province of Alberta, Saskatchewan's oil industry remained relatively small, in part because of the different resource policies pursued by the two provinces. In their classic 1979 work *Prairie Capitalism,* Richards and Pratt provide a detailed account of these differences. According to them, it was largely foreign capital that spurred the early and rapid development of Alberta's oil industry, while in Saskatchewan debates about public ownership and development of resources within and between the Co-operative Commonwealth Federation (1944–64) and New Democratic Party (1971–82) governments and their parties led foreign capital to perceive an unpredictable climate for investment.

Ultimately, the agrarian populist CCF government opted to keep the government out of oil. In 1949, Premier Douglas delivered letters to oil companies assuring them that the province would allow the "maximum exploration and development ... which natural circumstances will permit," and that "it has no intention of either expropriating or socializing the oil industry."[2] Douglas's goal was to avoid stagnation relative to Alberta by assuring the industry that the government was not anti-business. Thus the CCF

government took a passive approach, giving up its ideals of control over the timing and level of resource investment and conceding to low resource royalties.[3]

Discussions about more active government involvement in oil and other resource sectors resurfaced during Blakeney's NDP governments in the 1970s, which pursued a more active role for the state in resource policy, development, and royalties, most famously demonstrated by the nationalization of the potash industry. In 1973 the Blakeney government established the Saskatchewan Oil and Gas Corporation, known as Sask Oil, and the company began modest exploration, having drilled a total of only 130 wells by 1977. The Crown corporation also purchased some producing wells, but the scale of these activities remained small. Still, in 1981 Sask Oil had $191 million in assets, $60 million in revenues, and contributed $26 million in royalties to the government.[4] Following the 1973 OPEC oil shocks that drastically increased the world price for oil, and thus the profits of oil producers, the Blakeney government increased oil royalties and, alongside Alberta, introduced an excess profits tax. Between 1972 and 1982 the share of the excess profits returning to the government of Saskatchewan rose from 13 percent to 65 percent.[5]

Government involvement in the oil industry, however limited, was reversed when Grant Devine's

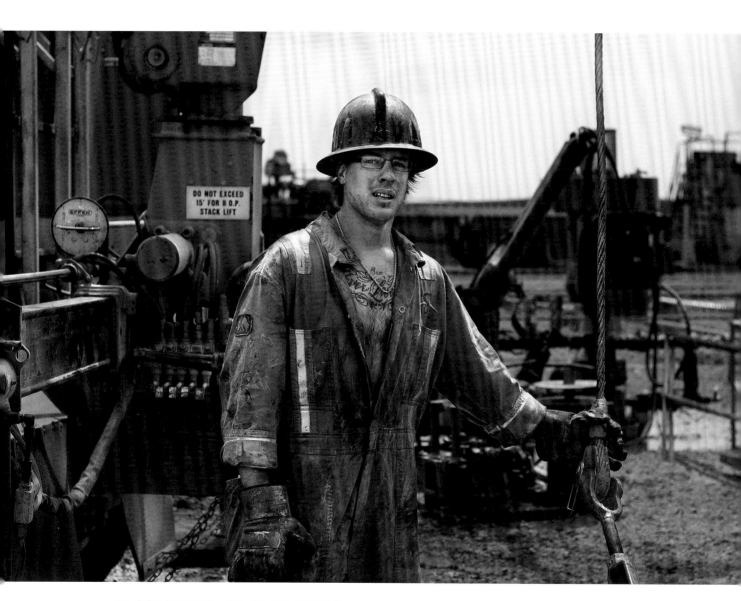

13. ROUGHNECK - RM OF ARLINGTON

Progressive Conservative government came to power in 1982. In 1985 Devine's government began selling off Sask Oil, a process completed under Roy Romanow's NDP government in the early 1990s. Royalty rates were also rolled back, first by the Conservatives and subsequently by the NDP government, down to a rate of 15 percent.[6] Since the 1980s, private oil companies have enjoyed an environment of decreasing government involvement, lowered royalties, and a variety of drilling incentive programs. However, the relationship between government involvement and the oil industry's relatively slow rate of growth (until the 1990s) is often exaggerated. Throughout the CCF and Blakeney governments, the level of government involvement was marginal and oil royalties remained competitive with Alberta.[7] Moreover, oil companies remained in the province and still turned a profit, even during the years of higher royalty rates and competition from Sask Oil.[8] Regardless of this minimal government involvement, it is likely that perceived uncertainty led some investors to choose neighbouring Alberta over Saskatchewan—though other factors such as favourable geology also contributed to such decisions.

The relatively small industry in Saskatchewan did not preclude peaks and troughs in production, resulting in uneven development over time. A period of growth starting in the 1950s had peaked by the mid-1960s, and the early 1980s saw a period of low production coinciding with low world oil prices. The most significant growth in production has happened since the 1990s, during which time provincial production went from below 80 million barrels in 1990[9] to over 177 million barrels in 2013.[10] Much of this dramatic growth is due to advances in horizontal drilling that have increased the productivity of wells and to world oil prices reaching new heights in the 2000s. Combined with multi-stage fracking, horizontal drilling has allowed for the production of oil previously trapped in small pockets in shale formations and therefore out of the reach of oil companies. By injecting water and sand under high pressure, shale formations are now fractured and propped open, allowing oil to flow to the well.

The combination of high oil prices, horizontal drilling, and multi-stage fracking has been heralded by industry enthusiasts and governments as part of a broader shale oil revolution that is challenging the forecasts put forward by peak oil analysts. In the U.S., North Dakota's Bakken formation is expected to propel the country into net energy self-sufficiency over the next decades. In Saskatchewan, multi-stage horizontal fracking has been responsible for aggressive shale oil drilling programs in the Bakken formation in southeast Saskatchewan, in the Shaunavon formation in

14. ADRIAN'S TRAILER - LLOYDMINSTER

the southwest, and in the Viking formation in the province's west-central region.

While production statistics show that the industry has more than doubled its production since the 1990s, they do not capture the regional booms associated with multi-stage fracking. Such booms are sustained more by aggressive drilling programs than by the productivity of the wells. After all, the flurry of economic activity that surrounds the drilling process is much greater than the labour needed to sustain producing wells. Furthermore, the productivity of many shale oil wells declines rapidly after the first few years, meaning that overall production volumes can only be sustained by intensive drilling. From 2006 to 2012, for example, over 2,000 new wells were drilled in the Bakken formation and, during the same period, more than 2,000 new wells were drilled into the Viking formation.[11] In fact, new drilling proceeded in the Viking during years of declining production from 2004 to 2008.[12]

It is not only the shale oil fields that have benefitted from the high price of oil. The heavy oil fields around Lloydminster have also seen steady growth and new drilling initiatives in the 2000s due to investments in thermal extraction technologies such as steam-assisted gravity drainage as well as a lower price differential between heavy and lighter oils.

Here the oil economy also includes the upgrading and refining capacity in Lloydminster.

Saskatchewan's recent oil boom coincided with a broader economic boom in the province (dubbed "Saskaboom") and has contributed to a palpable sense of excitement and energy. But the collapse of world oil prices starting in the fall of 2014 called into question the future of Saskatchewan's oil boom. Suddenly, the government froze discretionary spending and hiring, drilling rigs left the province, and oil companies asked their contractors do more work for less compensation. There is no doubt that rural communities are already experiencing the negative impacts associated with the bust. Unemployment and vacancy rates are on the rise, and in one major oil-producing city a long-standing hotel and bar has announced it will close. It is yet too soon to understand the depth and breadth of the impacts of the bust. But since oil prices are not expected to rebound any time soon, rural areas are bracing for a long downturn.

15. ROLLING GREEN RV PARK - LLOYDMINSTER

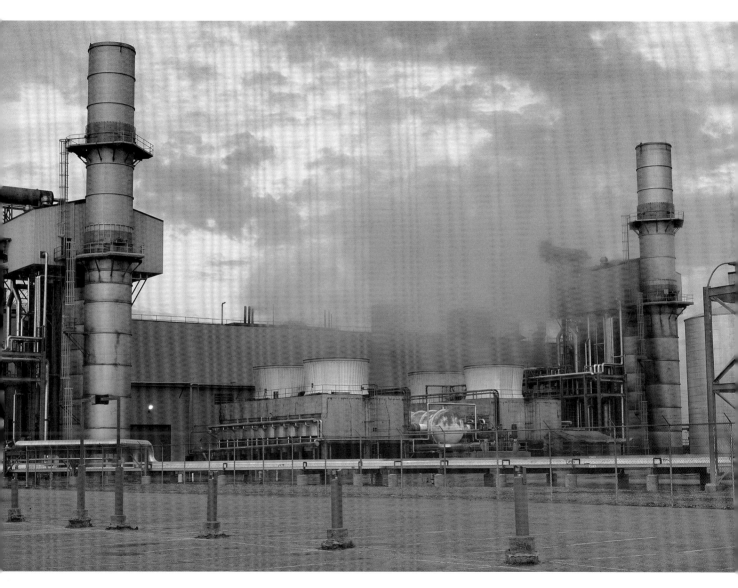

16. UPGRADER - LLOYDMINSTER

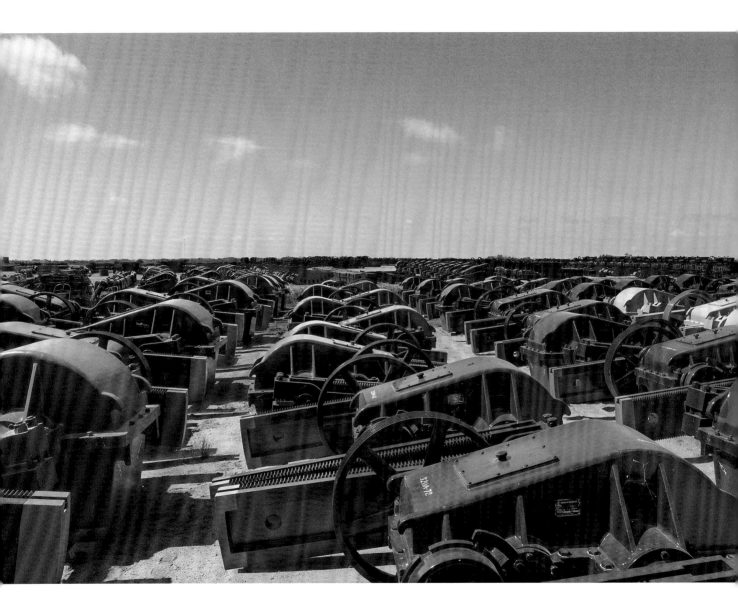

17. PUMPJACKS - LAMPMAN

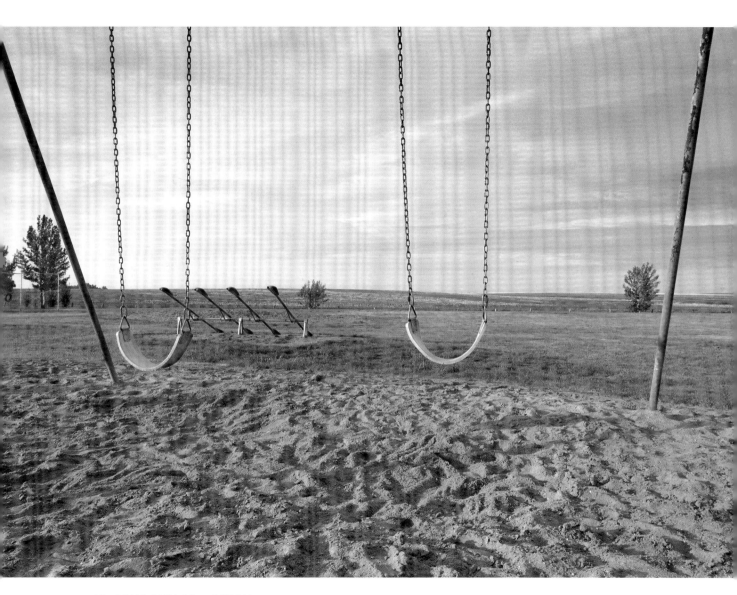

18. SCHOOLYARD - ESTON

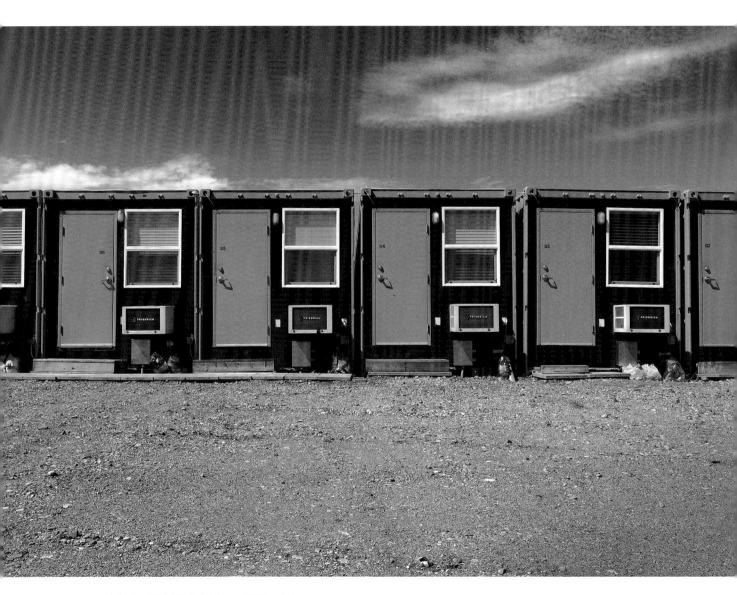

19. CANSTAY MOTEL - ESTEVAN

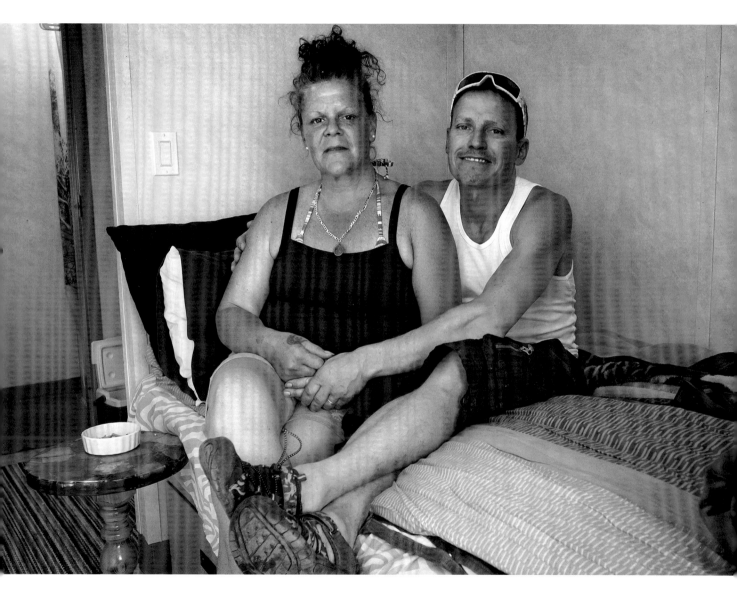

20. TERESA AND JULIAN - ESTEVAN

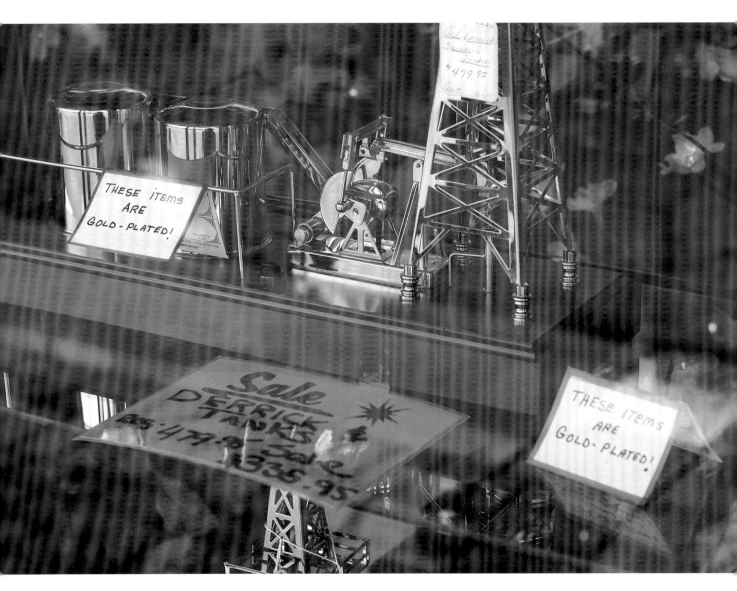

THESE ITEMS ARE GOLD-PLATED!

Sale
DERRICK & TANKS
~~335~~ $479.95 Sale
$335.95

THESE ITEMS ARE GOLD-PLATED!

21. SHOP WINDOW - LLOYDMINSTER

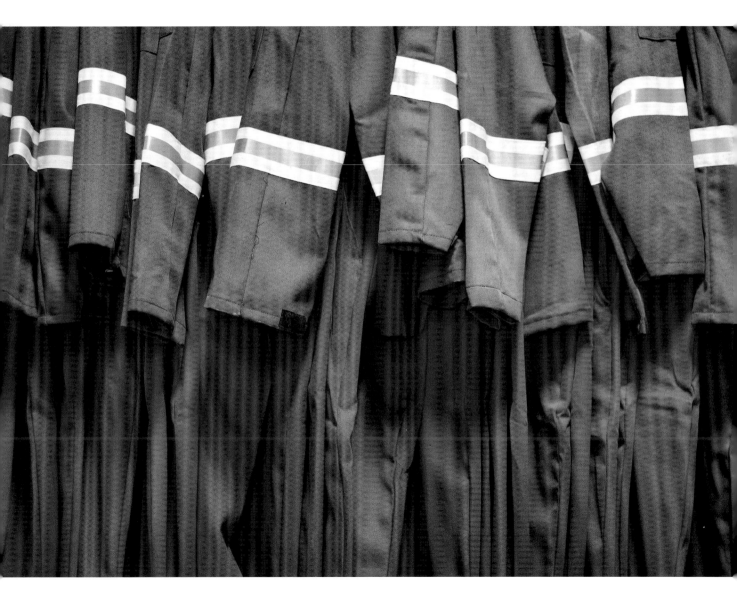

22. COVERALLS - SHAUNAVON

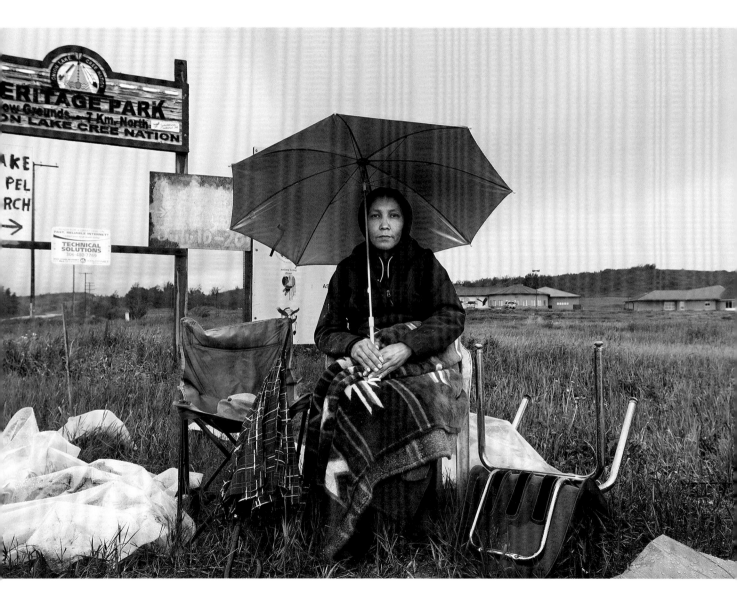

23. HUNGER STRIKE - ONION LAKE CREE NATION

HOSTING THE OIL INDUSTRY

*"There's no motherhood and apple pie in
the oil industry."—Landowner*

In the business of oil, the separate ownership of
surface and subsurface property rights causes a
lot of headaches. For the majority of farmers and
ranchers in Saskatchewan, who own only the sur-
face rights to the land, the income they derive from
hosting oil leases is small, ranging from $2,000 to
$3,500 per year per lease with a single well. As es-
tablished in the Saskatchewan Surface Rights Ac-
quisition and Compensation Act, surface leases
are meant to compensate surface owners based on
the agricultural value of the land, the loss of its use,
adverse effects, nuisance, damage, and costs associ-
ated with severing leases from larger tracts. Thus,
the perception that landowners are getting rich
from hosting infrastructure is largely false: by the
definition of the Act, they are being compensated
for the lost agricultural use of their lands. At this
rate of compensation, farmers must play host to a
large number of wells in order to make a substantial
income from surface leases. Nevertheless, in Sas-
katchewan's oil-producing areas, many landowners
welcome new surface leases and use the stable oil

income to supplement inconsistent farm incomes
that result from fluctuating commodity prices and
unpredictable weather and pests. For families try-
ing to resist farm consolidation and corporatization,
oil lease income, though only meant to compensate
for lost agricultural use, can be the difference be-
tween selling the farm and staying on the land.

Farmers and ranchers who own mineral rights are
few and far between in the province—just 25 per-
cent of Saskatchewan oil rights are held in private
hands (known as freehold rights), and these rights
are not always held by the same surface owner. Un-
like surface rights owners, private mineral rights
owners are compensated handsomely through
annual payments of oil royalties that provide them
with a substantial ongoing income that more than
accounts for the nuisance of surface leases. Thus, in
any given landowning community, a complicated
landscape of oil interests structures farmers' and
ranchers' relationships to the industry.

While many rural landowners welcome new oil
leases, others have become unwilling hosts to oil

29

infrastructure. When mineral rights are sold, either by the Crown (which holds 75 percent of mineral rights in the province), or by other private owners, surface owners have no recourse; they must allow companies onto their lands in order to access the oil. Surface rights legislation provides companies legal access to their minerals through a "right of way" regardless of the surface owners' wishes and without consideration given to the families who have stewarded the land and made their livelihood from it for generations. Referencing Thomas King's book *The Inconvenient Indian,* one rancher I interviewed suggested there is a parallel to be drawn between the displacement of Indigenous peoples through colonization and the situation of ranchers who find themselves in the way of the oil industry. According to him, "We are now the inconvenient landowner."

Even if the landowner refuses the terms of a surface lease, an oil company can obtain a right of entry, provided through legislation, and be drilling within two weeks of the breakdown of negotiations. This has led members of the Saskatchewan Surface Rights Organization to argue that leases are one-sided. Without the right to say no, landowners are without bargaining chips in the negotiations. Those renting farmland (increasingly the case as rural areas become depopulated and landowners become absentees) are worse off,

without even the chance to negotiate the range of provisions that some landowners have been able to achieve—including specifications related to lease maintenance and reclamation.

Ranchers and farmers who have become unwilling hosts to oil infrastructure have many colourful expletives to describe the companies whose oil wells, batteries, tanks, drilling rigs (photos 10, 61), disposal pits, flare stacks, flow lines (small pipelines connecting individual wells to batteries and tanks), and power lines are unwanted intrusions on their lands. These landowners have a broad range of complaints related to the oil infrastructure in their backyards (photos 32, 63), whether or not they initially welcomed the oil leases. The most common complaints of the landowners interviewed for this research have to do with how oil leases disrupt the practice of farming and ranching. During their (regulated) daily checks on wells companies leave gates open—causing animals to escape, plug up Texas gates with mud, and bring unwanted weeds onto lease sites, causing disruption to crops. Access roads and flow lines fragment fields because farm equipment cannot be driven over them. Wells are often placed in the most inconvenient and ecologically sensitive locations. Drilling operations compact soils and mix up soil horizons, compromising crops on lease sites. Companies leave behind garbage that blows across fields. Animals become sick and even die when they

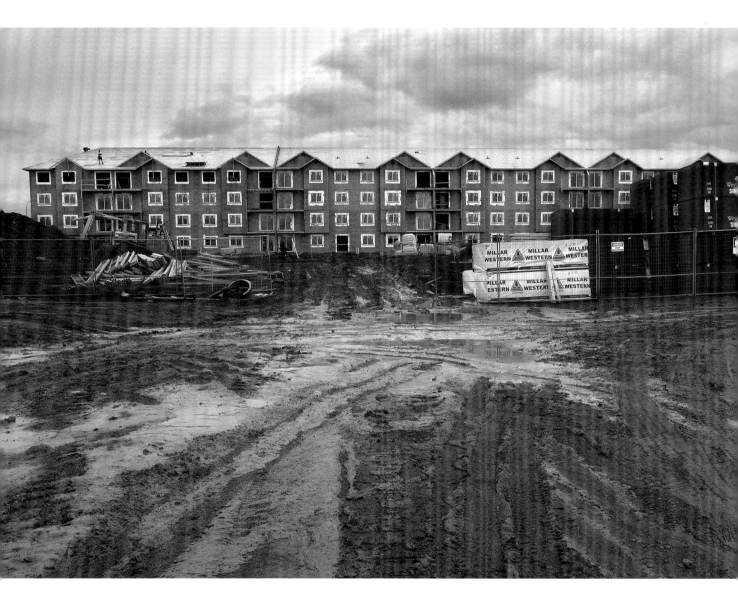

25. CONSTRUCTION - LLOYDMINSTER

ingest debris left on lease sites or, on rare occasions, get caught in pumpjacks. Citing such incidents and hassles, many landowners argue that the $2,500 they get for a lease doesn't even cover the associated costs to the farming operation.

Some landowners also feel that their health is being negatively impacted by the infrastructure on their lands. They speak about persistent coughs and sore throats, and point to itchy red eyes as evidence that Saskatchewan's oil regulators have little regard for rural residents and invest inadequately in industry oversight. In a series of reports released by the Canadian Broadcasting Corporation (CBC) in 2015, regulators admitted to widespread and chronic problems with wells across the province leaking gas containing hydrogen sulphide, a gas that has caused serious harm and death to animals and oil workers in the province.[13] According to the CBC, 70 percent of the eighty-four sites inspected in a 2014 audit conducted by the Ministry of Economy were found to be emitting well above regulatory allowances.[14] The eighty-four sites were chosen for inspection because they were located near people's residences and posed a danger to human and animal health. However, residents' health concerns are largely unconfirmed because health studies and data are not being conducted and collected in these rural areas.

More severe land impacts experienced by ranchers and farmers include leaks and spills, the most damaging of which are caused not by oil, but by highly salinated water. In fact, in many ways the oil industry is more accurately in the business of waste management, given that they must properly dispose of the water that accounts for 75 to 95 percent of each barrel extracted. The sheer volume of "produced water" that companies must dispose of at their own cost means that the potential for spills is significant. One landowner in the southeast of the province has a particularly remarkable story regarding a battery site that he has been fighting to get cleaned up since the 1980s. A leaking salt water tank had not only destroyed the battery site, but the land surrounding the site was no longer suitable for crops because of high levels of soil salinity. According to this landowner, successive companies that had taken over the lease had hired environmental consultants to study the site, but the studies had piled up over the years without any action. While spilled oil will biodegrade over time, salt is a persistent contaminant. Proper remediation would have included digging out the damaged soil and replacing it, but successive companies attempted to deal with the problem by flushing out the site with water. This only spread the salt further into the landscape and into surrounding surface water and dugouts. Exasperated, this landowner no longer has any faith that the contamination will ever be cleaned up. Not even

26. ROUGHNECK - RM OF ARLINGTON

the regulators, who had been out to see the site, seemed to be able to force the company into action. As he explains, government "will tell you that they have a big stick that they can swing, but they don't swing it. Grow the economy. Environment can come later. [With] all the money we made growing the economy now we can take it and clean up the environment. That's how smart they are."

In another case, a rancher in the west-central region experienced a major pipeline leak on his land. So much oil was spilled that when the company came to notify the rancher and his wife in the middle of the night, they told them to pack their bags and leave their property on foot to avoid turning on their ignitions. The couple stayed in a hotel in a neighbouring town for a month while the spill was being cleaned up. Returning to his property daily to check on his animals, the rancher found the smell difficult to take and the animals huddled in the corner furthest away from the spill. When a company representative came out to brief the rancher about the cleanup, the rancher advocated aggressively that thorough and swift remediation measures be taken. In response, the company representative reminded the rancher that his grandson drove a steam truck for the company, suggesting that his job might be terminated should the rancher be too demanding.

This rancher's story illustrates the extent to which the oil industry's deep penetration constrains and shapes individual landowners' abilities to advocate for themselves and their land. In the context of a declining and consolidating agricultural economy in rural Saskatchewan, the oil industry offers one of the only and best opportunities for employment. In fact, on top of hosting infrastructure, many landowners are also contracted by the industry. In addition to running their farms, farmers might truck for oil companies or even work on drilling rigs. On a more informal scale, landowners offer services such as snow removal, weed control, access to surface water, disposal of drilling mud, and much more. Many of these landowners are the same ones who complain of inadequate surface lease compensation and the nuisances outlined above. Landowners are thus in a complicated and ambiguous position vis-à-vis the oil industry; they are stuck with the oil leases and are attempting to make the most of their situations. They wrestle with the question of whether the surface lease income properly compensates them for the nuisance, and they worry about the safety of infrastructure as it ages. For these reasons, many criticisms of the industry are preceded by caveats like "I'm not anti-industry, it has done wonderful things for our community and my children, but..."

A rancher affectionately nicknamed "Wild Bill" (photo 5) effectively illustrates this ambiguity.

27. CENTRE STREET - CADILLAC

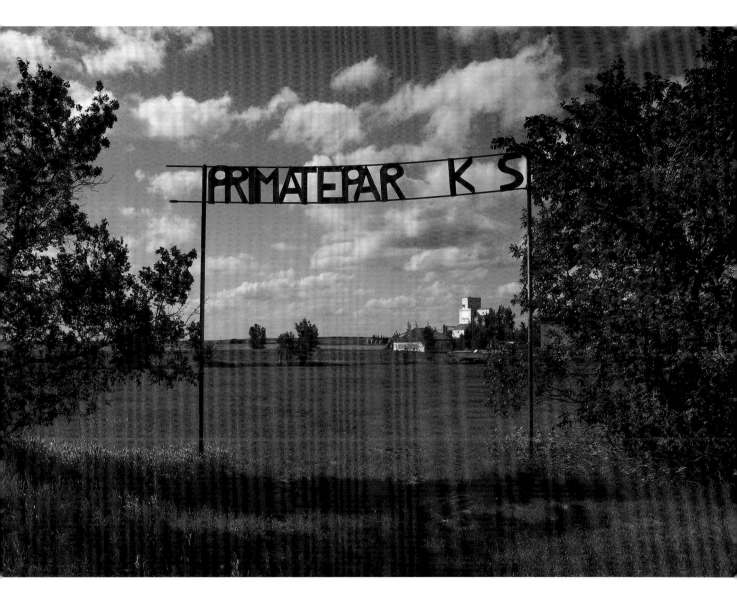

28. TOWN PARK - PRIMATE

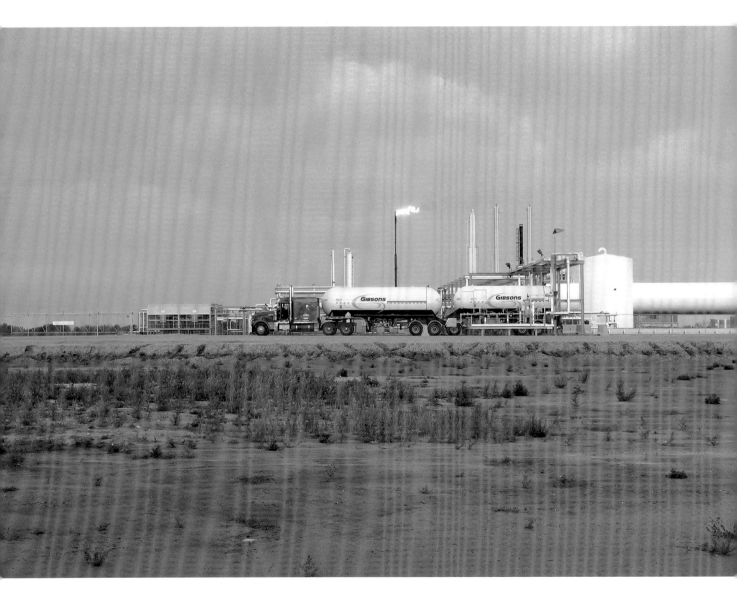

29. GAS PLANT - RM OF TECUMSEH

31. DEALERSHIP - SWIFT CURRENT

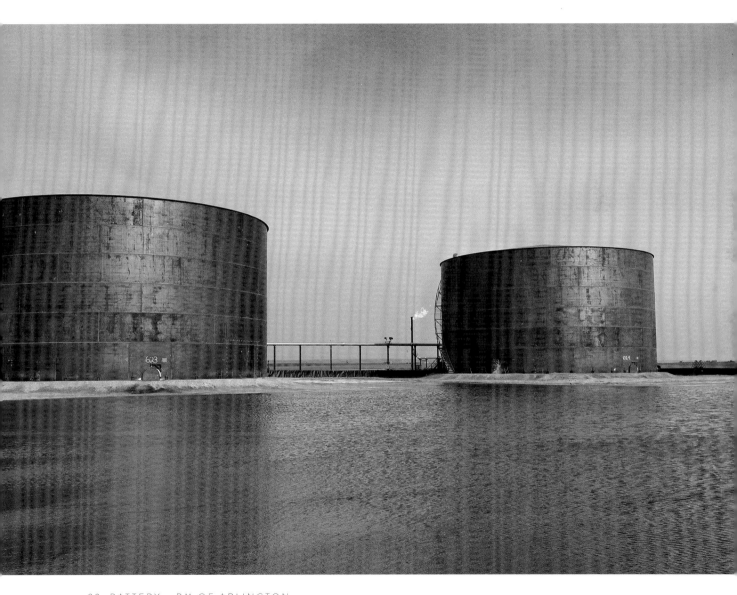

32. BATTERY - RM OF ARLINGTON

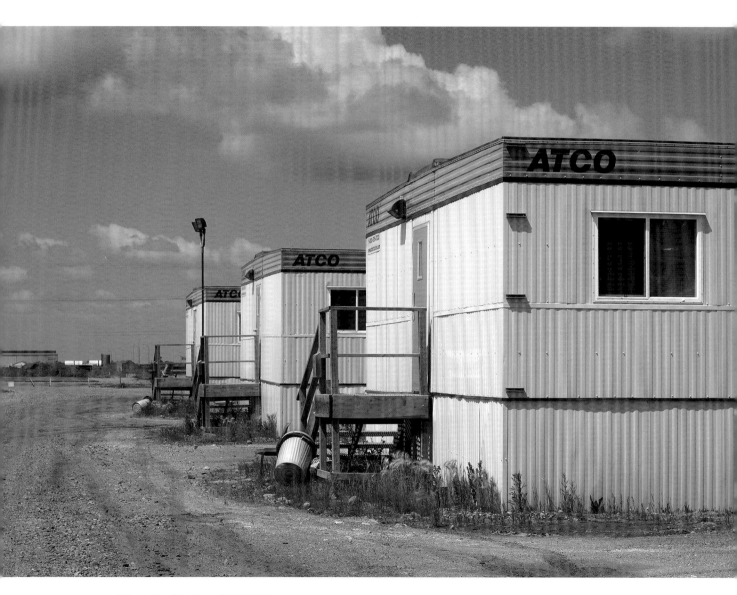

33. MAN CAMP - ESTEVAN

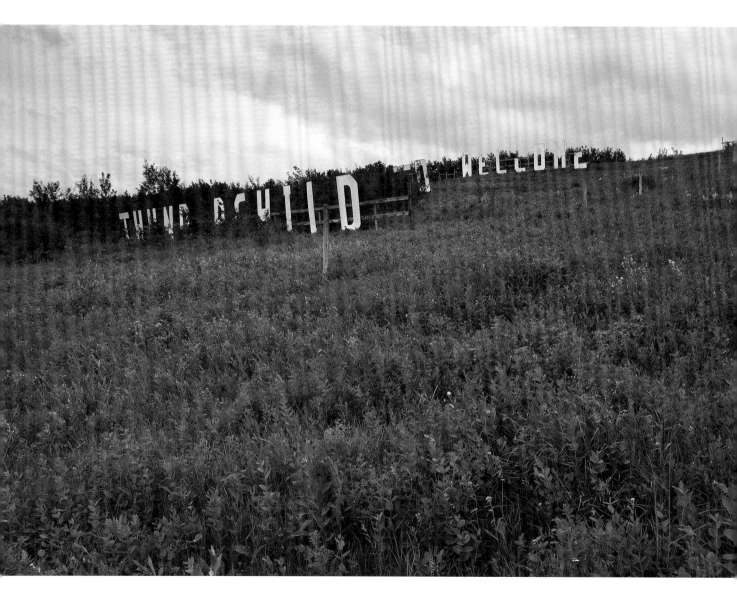

35. WELCOME - THUNDERCHILD FIRST NATION

While he painstakingly explained the nuisances and showed me the damage caused by oil leases in his community, he had little to say about these negative land impacts in front of the locals at coffee row (photo 48). Introducing me as someone who does research on the impact of oil, he commented, "Well, I'll tell you one thing, there probably isn't a one of us around this table that hasn't seen a cheque from oil at one time or another, that's one impact." Indeed, the men had all either worked directly in the industry, serviced the industry through trucking or other contracts, or hosted oil infrastructure on their farms. "If there were no oil, there would be no Coleville," one added.

In this context of tight ties and involvement with industry, advocating for proper compensation and remediation of contaminated lands is problematic. If a landowner is not actively working for an oil company, it is sure that their child, grandchild, sibling, or other family member is. As I was told by several interviewees, in small tight-knit communities nobody wants to be seen as anti-oil, as that would endanger the prosperity of their neighbours and family. Criticisms of the environmental impacts of extraction are deemed particularly off-limits, even though farmers and ranchers understand themselves as stewards of the land. For the most part, landowners struggle through the environmental, health, and land-management impacts in silence.

One of the only organizations in Saskatchewan that advocates for those experiencing the impacts that come with hosting oil infrastructure is the Saskatchewan Surface Rights Organization. Organized into regional "sections," surface rights groups are engaging in a form of self-help. The west central section has hired a former "land man" who used to be contracted by oil companies to negotiate surface leases with landowners, and therefore has inside knowledge of the industry. This former land man helps individual landowners take their cases to the Saskatchewan Surface Rights Arbitration Board, where they can attempt to get limited compensation for nuisances and breach of the terms of leases. Landowners complain that the surface rights legislation does not allow for adequate compensation, and that the board members, appointed by the province, work in the interest of the companies rather than the landowners. Clearly there are limitations to this practice of self-help. While landowners are learning from each other's cases, the approach remains a fundamentally individual one and is limited by the terms of the surface rights legislation. Furthermore, some landowners report being typecast as anti-industry for their involvement with the organization, and there are likely many more too timid to even pursue their cases with the surface rights groups. According to one rancher active in a surface rights organization, his neighbours "wouldn't join the surface rights

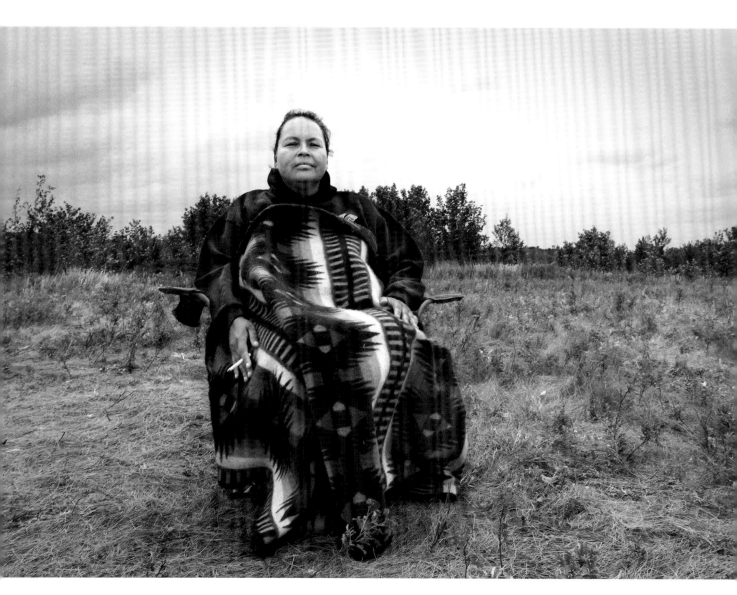

36. AFTER THE SUNDANCE · THUNDERCHILD FIRST NATION

group because they plough snow in the winter time for the oil wells, so there's a conflict of interest and a lot of farmers that plough snow and stuff, they're scared to associate themselves with us. But I don't think that the oil companies are too upset about it." A cultural attitude of independence and masculinity also precludes landowners from getting together. As one farmer said, "There's also a cowboy mentality. It's you alone against the elements and the world and why should you associate? I mean, 'I'll look after myself. I've got a six-gun and I can handle these guys.'"

Importantly, landowners have to be actively checking up on oil infrastructure and meticulously documenting oil impacts if they wish to advance a case through surface rights arbitration, or through individual negotiations with oil well operators. Some fear that the increasing incidence of absentee landlords is changing the relationship that landowners have to their land. For urbanites living in Vancouver, Calgary, or Saskatoon, inherited land is increasingly understood as a source of surface lease income and less utilized by the owner for farming and ranching. For these landlords, oil impacts may be becoming less visible.

While much of the oil development in Saskatchewan happens on lands where the surface is owned privately by individual ranchers and farmers, some wells are located on publicly held Crown lands or on First Nations reserves. Through the ongoing transfer of the federally operated Prairie Farm Rehabilitation Administration's (PFRA) community pastures, the province will acquire a significant number of oil and gas wells—around 4,500 in total. The PFRA was created by the federal government during the "dirty thirties," when a long drought compromised many lands and livelihoods. Since its establishment in 1935 it grew to acquire 1.5 million acres of land, upon which it operated a successful land management system that fostered and revived native prairie, grazed cattle for a fee for local farmers, and built irrigation works. In interviews, current and former PFRA staff worried that the province doesn't have the same capacity to monitor the compliance of oil and gas companies or negotiate the same standards of environmental protections as the PFRA. In the words of one former PFRA employee, "one of the problems with the province is they are extremely short staff[ed] ... there's been no time for any lease inspections." Another suggested that "the environmental quality of the pastures is going to go down [when they are transferred to the province]. There isn't going to be the oversight for oil and gas ... if we try to forecast what kind of management these lands are going to have we just have to look at the provincial Crown lands. They don't do range condition assessments, they don't do range management planning, they

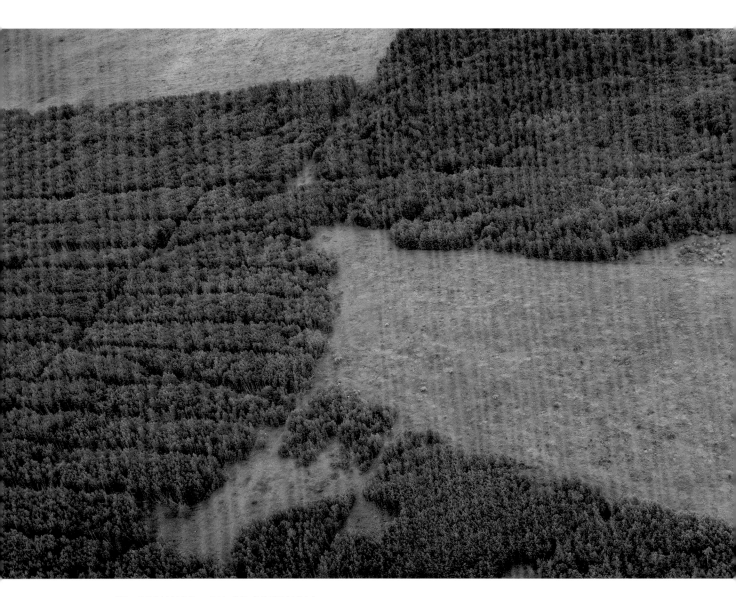

37. CUTLINES - RM OF BRITANNIA

don't have the weed control programs. They aren't doing Species at Risk [Act] at all." According to these interviewees, many of the PFRA practices that mitigated impacts associated with oil and gas will be compromised, there will not be the same level of protection of native prairie and, thus, of crucial habitat to many species at risk.

While very few First Nations reserves are located within the oil-producing areas of the province, there are a few notable exceptions. Onion Lake Cree Nation, located just north of Lloydminster and straddling the border with Alberta, is one of the top oil-producing nations in the country, and White Bear First Nations, located in the southeast, is also now producing oil. If rural settler communities see the oil industry as one of their only chances for long-term survival, the situation is even more desperate on reserves where economic development opportunities are few and far between. On these reserves, chiefs and councils are negotiating joint ventures with oil companies and setting up oil field service businesses in order to capture some of the spin-offs. While oil is relatively new to these reserves, there are already grumblings of dissatisfaction about how oil infrastructure is impacting hunting, gathering, ceremonial practices, and strong convictions among some land defenders that oil extraction is inconsistent with Indigenous relationships to the land. On the other hand, band councils point to Indigenous-owned companies that service the oil industry and to the resource royalties accruing to some bands as concrete benefits to First Nations.

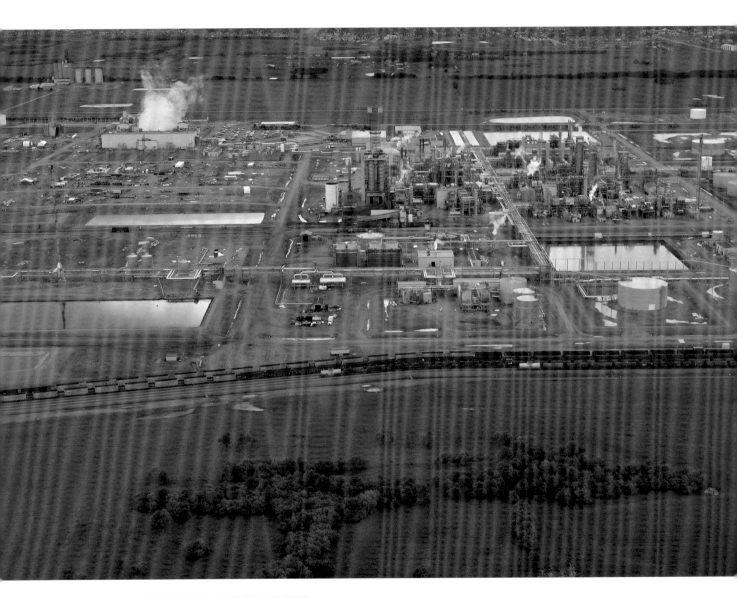

38. UPGRADER - LLOYDMINSTER

WORKING THE OIL INDUSTRY

Saskatchewan's oil industry is dispersed across many different landscapes and involves both short spurts of intense work—for example in the drilling and construction phases—and longer-term maintenance of and collection from a vast, distributed infrastructure. In contrast with developments like Alberta's tar sands, there are few large-scale industrial projects with unionized workforces in Saskatchewan's oil industry (the refining and upgrading facilities in Regina and Lloydminster [photos 16, 38] are the two industrial sites). Instead, workers (predominantly men) labour in non-unionized work environments in a hierarchical system of contracting out. Unlike in other industries where a professional managerial class directs production, in the oil industry many of the higher-paying jobs outside of company headquarters are occupied by men who started out as roughnecks or general labourers and worked their way up to the position of oil field consultant. Many have a strong belief in the self-made man and eschew the need for unions. Often, they enjoy working outdoors, feel they are well-compensated, and pride themselves on the physically demanding nature of their jobs.

However, the long hours and on-call shifts mean that many see their oil jobs as temporary means to a more permanent end that often includes a family and a house in a more urban centre.

It is either feast or famine in the oil industry. In general, oil field workers are handsomely compensated. As rancher Bill Dillabaugh from Coleville (photo 5) suggests, "If you can spit and walk, you're thirty-five dollars an hour here." General labourers can find all sorts of jobs in the many companies that contract to oil companies, often without the requirement of grade twelve. Such labourers can make between thirty and thirty-five dollars per hour working twelve-hour shifts in various rotations with as many as ten to twelve days in a row before they see a day or two of rest. Some even pick up shifts on their few days off. In a good year, they can pull in $100,000 or more. Other more specialized work, involving either lots of experience or more specialized training (in the case of electricians and engineers) is even better compensated. However, oil field work also comes with a whole lot of uncertainty. During the spring, when

39. WATER TOWER - ESTEVAN

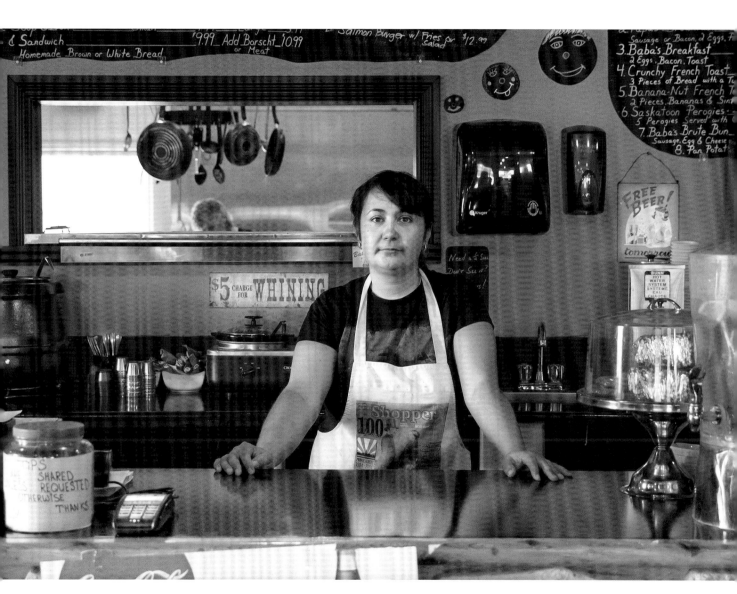

40. TANYA - ESTEVAN

41. FOURTH STREET - ESTEVAN

42. JORDAN - SHAUNAVON

43. FLOW LINES - LLOYDMINSTER

44. ST. CHAD'S CHURCH - SCEPTRE

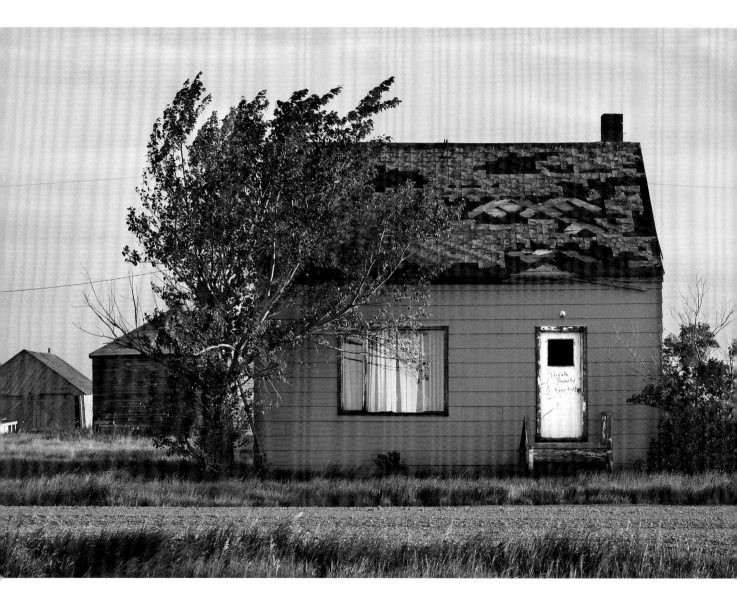

45. "KEEP OUT!" – RM OF SNIPE LAKE

municipalities impose road bans on heavy traffic in an effort to conserve grid roads, many people are without work. Known as "breakup," this period can last from four to eight weeks. In years of severe flooding, as was the case in 2011 in southeast Saskatchewan, rig crews have logged as few as ninety days of work. Uncertainties around work are not just seasonal—some oil workers have no set schedule at all; they do not find out until the day before at what time they work, and they do not go home at night until the job is done. Many workers are also on call, especially those driving trucks that vacuum up fluids or working other equipment that would be called out to deal with an unpredictable event such as a spill.

The uncertainties in scheduling and layoffs are produced by the industry's pervasive use of contracts. An oil company does very little fieldwork in-house: drilling, completion, well servicing, pumpjack inspection, battery operations, and lease maintenance are all performed by specialized contractors, and rental companies provide a wide variety of equipment and services on contract. Thus, when production slows down due to weather, breakup, or other contingencies, contracts are simply not filled. For example, when oil prices fell dramatically in the final months of 2014, oil companies demanded that their contractors provide cheaper services. This flexibility transfers all the risk and

its management to contractors down the line who are the direct employers of the majority of oil field workers. One temporary foreign worker I spoke with emphasized the difficulty this poses for people on "closed" visas, where the temporary employment contract is associated with a single employer. After working for a company for four months, this temporary worker from Ghana was laid off alongside numerous other employees. Finding another employer to sponsor his temporary work visa, by no means an easy feat, was necessary in order for him to stay in the country.

Saskatchewan's oil industry remains predominantly a man's world. While visiting the town of Shaunavon I was lucky to meet and spend time with two women who offered a perspective on the gendered nature of the patch. Until recently, Mandy, twenty-two years old (photo 53), was a "swamper," riding in the passenger seat of a vac truck (a truck that vacuums up substances like water and drilling mud and hauls them away for disposal). When she obtained her Class 1 licence she graduated to the driver's seat and admits that she has not seen any other women in her position. Having left home at the age of fifteen, working at a hog barn, cleaning hotel rooms, and selling Mary Kay in whatever time remained to make ends meet, what she likes most about the oil patch is that she no longer has to piece together multiple jobs in order to make a living: "It's

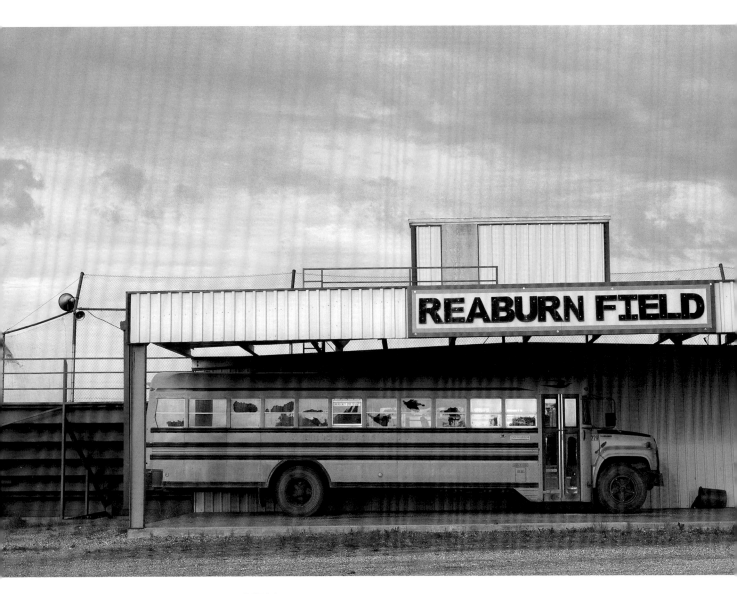

46. REABURN FIELD - ESTON

nice having one job. I may work a twelve-hour day, I may work a four-hour day, it doesn't matter. I don't have to go home and get ready for the next one. I can just go to bed if I want to."

Another woman I met in Shaunavon, named Stef (photo 64), has worked at a local oil field distribution centre for four years selling all sorts of products and services to oil field contractors. She works with and sells to men all day long and, as she puts it, "takes a lot of shit." In her sales role, she is less of an anomaly in the industry. As in most industries, office and sales work tends to be gendered as women's work. On top of her regular paycheque, Stef collects bonuses and health and pension benefits. She is proud that she makes a comparable annual income to some of the men working in the field. In exchange for the stable income that supports her and her two boys, she is always on call. At any time outside of her normal working hours of 8:00 a.m. to 5:00 p.m. she could be called in, often to sell products to contractors working to remedy an emergency. Office and sales work tends to be less affected by the seasonality and downturns of the industry, though certainly a slower oil patch would affect bonus pay.

Both Mandy and Stef feel that their work in highly male-dominated workplaces has affected their relationships with other women in the community. They cite pervasive "cheating" as a cause of "shitty"

relationships among women. According to them, most spouses of oil workers assume that their husbands work in male-only environments. Because of their close working relationships with men, they are the subject of suspicion and jealousy. Indeed, intense working relationships are characteristic of the industry. Workers labour in small teams of two (in the case of vac trucks) to five (in the case of a drilling crew [photos 11, 62]) people. They spend all day together driving long distances and rely on each other for safety. Little of the work in the oil field is individual in nature; hierarchies clearly delineate each team member's roles and responsibilities. For many, these intimate work relationships and the camaraderie they encourage are prized. However, for one general labourer I spoke with—a temporary foreign worker from India—these tight and hierarchical relationships were exclusionary. "It's good money working in the oil company," he told me, "but if we will talk about the work culture in oil fields, then they will treat you like shit...they are drillers and consultants, they will treat us, the normal labour, like shit."

Oil field work is risky work. Here again, the dispersed and contracted nature of production means that many people labour far away from the watchful eyes of regulators, and that contracting companies are incentivized to get the job done. During interviews, I heard many stories about the lack of

47. THIRD AVENUE - SHAUNAVON

safety precautions that characterized the industry "back in the day" when men went out into the patch without the proper safety equipment and frequently high on drugs and alcohol. The frontier mentality of oil culture has been captured through literature and film, and is reproduced in workers' stories about the past of Saskatchewan's oil fields. However, most people are careful to emphasize that the culture of safety in the province is improving. One crew member from a drilling rig explained, "Guys are starting to take safety into their own hands, more and more. It's not just 'What does the company tell you to do,' but other guys are looking out for you too.... Do I feel safe? Absolutely. But it's also because of the crew you're on, because as I said, the guys take safety into their own hands. There's only so much the office can do."

Still, oil field workers die every year on the job. Perhaps the most pernicious threat comes from being lethally exposed to gaseous hydrogen sulfide (H_2S), commonly found in oil deposits and a by-product of extraction. Every year or two a death related to the poisonous gas is reported. More commonly, workers suffer physical injuries from being exposed to harmful substances, falling, exertion, or coming into contact with equipment. According to Enform, the safety association for the upstream oil and gas industry in Saskatchewan, oil well servicing accounted for the majority of the

lost time associated with accidents and injuries in the industry in 2013 and 2014.[15]

While industry associations such as Enform have promoted workplace health and safety through training programs, resources, and certifications, cultures of workplace safety vary across contractors. One worker at an oil field construction company provided a simple example. Regulations require oil field workers to wear H_2S monitors and to test them every day on specialized equipment available at the company shop. However, workers are often told not to come in to the shop before their shifts. Rather, when the first site of the day is a good distance from the shop, workers are told show up on site. But this precludes proper safety testing of H_2S monitors because most company shops don't open until after workers are due on site. Thus, according to this worker, employees at some companies are encouraged to play fast and loose with the rules, with daily tests of the safety equipment happening mid-shift rather than beforehand. Interestingly, the responsibility for monitoring and documenting company safety policy often falls to women, perhaps because of an implicit stereotype about the safety consciousness of women but also because it is largely understood as paperwork.

The long hours, few rest days, and time spent away from loved ones is taxing on what one psychologist

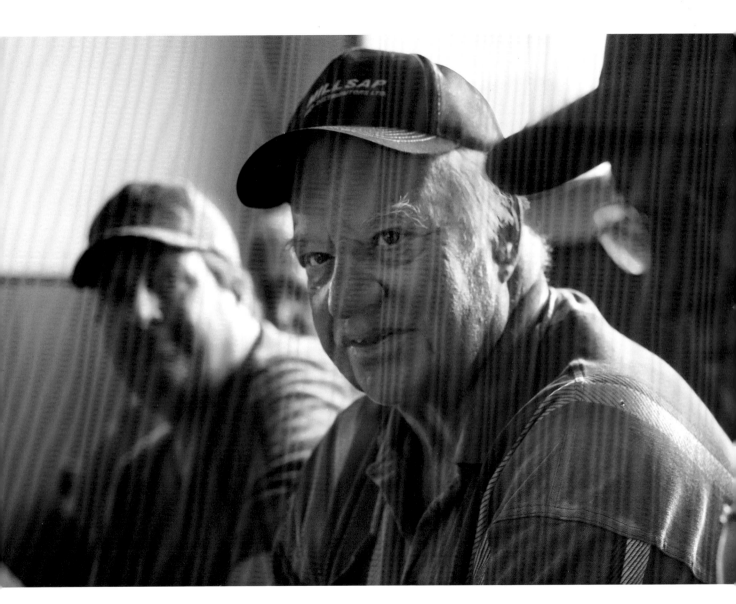

48. COFFEE ROW - COLEVILLE

I interviewed called "the family unit." Many oil workers were brought up and reside in the small communities that surround Saskatchewan's oil patch and lead traditional family lives that include spouses and children. However, according to this psychologist, who sees many of them as patients, spouses of oil field workers are increasingly identifying as single moms. This phenomenon is only exacerbated in the case where oil field workers commute hundreds of kilometres, sometimes from neighbouring provinces, following short-term contracts. In a campground I stayed at in Lloydminster (photo 74), the weekends were distinctly different. Those who had a couple of days off left their trailers to travel home to their families, and others hosted children and partners who travelled to spend time with them at the campground. However, the sights and sounds of children playing were always temporary. The psychologist explained that many of his patients experienced family breakdown and divorce, not during these long periods of separation, but after men returned home more permanently. Such men had a hard time reintegrating into the family, since routines and social supports had all been built around their absence. In these contexts, men often felt unneeded and unwanted.

Finances are often a source of family stress in the oil patch. The feast-or-famine nature of the industry leads many into cycles of over-consumption fuelled by debt. One faith leader I spoke with believed that financial counselling was needed for his community. According to him, "Guys come in here—I say guys because [typically] it's guys—and they look at how much they make in the first three months they're here and it's exorbitant. And they figure that's the baseline. Not taking into account the fact that probably 60 percent of that is overtime money. And the overtime always dries up at some point, whether it's breakup or something else. And they've developed a lifestyle, they've taken on a mortgage, they've done all these sorts of things, vehicle payments, because everybody's got to drive a $60,000 truck here. They take on a vehicle payment and then when the overtime dries up there's no way they can make the payments."

If the cyclical nature of the industry causes household financial problems during times of boom, the oil price collapse starting in 2014 has caused only worse and more prolonged suffering for many families. Living through an oil boom is expensive, even for those making oil field wages. But it is especially difficult for those servicing the oil industry, who make a fraction of the oil field wages but must contend with inflated housing and consumer prices.

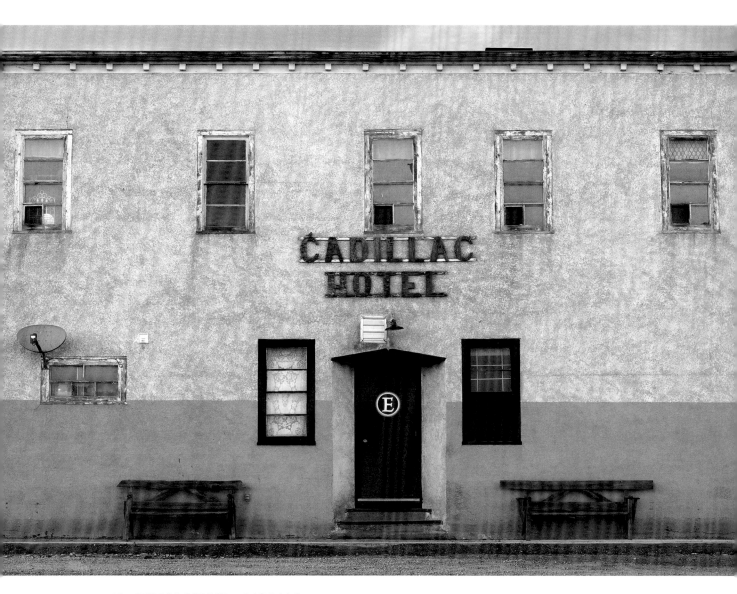

49. CENTRE STREET - CADILLAC

50. FRONT YARD - SWIFT CURRENT

HOME OF
BRAYDON
COBURN

Home of HAYLEY
WICKENHEISER

51. TOWN ENTRANCE - SHAUNAVON

52. EMPTY LOT - SHAUNAVON

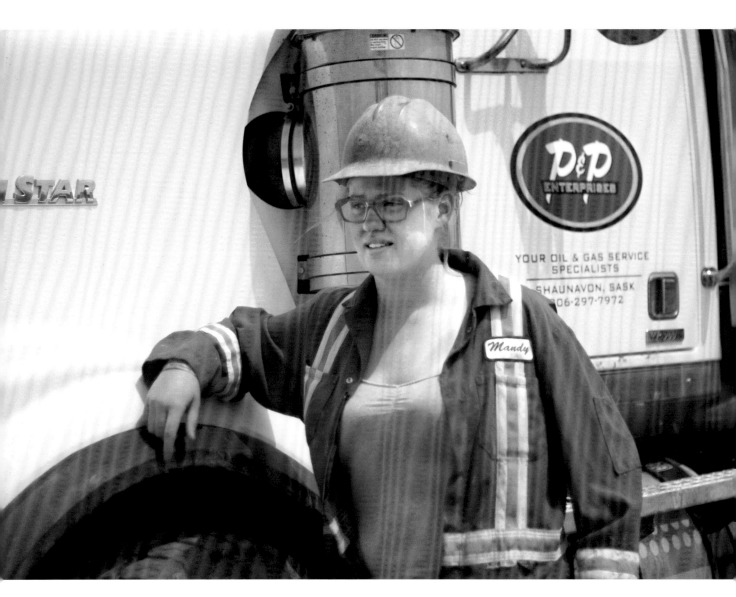

53. MANDY - SHAUNAVON

SERVICING
THE BOOM

In the small towns of Saskatchewan's booming oil patch, rapid growth has strained social services such as mental health and addictions counselling; inflated housing prices; decreased rental vacancy rates to nearly zero; and drawn workers from across Canada and overseas. In the summer of 2014 the average rental price for a two-bedroom apartment in the city of Estevan, in the heart of southeast Saskatchewan's oil patch, was $1,275 per month, more than the average price for similar accommodation in Canada's top three metropolitan cities, Vancouver, Calgary, and Toronto.[16] While such prices may be within the means of oil field workers, they can scarcely be afforded by those who service the oil industry, including hotel, restaurant, and bar staff; by those living on fixed incomes; or by others working in sectors that do not make oil field wages. In oil towns, local employment, infrastructure, and social services are all oriented around servicing the oil industry and its workers, yet inequalities characterize the sharp division between oil work and the work of servicing the boom.

Booming oil towns attract people of all sorts fleeing un- and underemployment in economically depressed regions of Canada and the world, or looking for a new start in life. According to one mental health professional I interviewed, the influx of workers happens in waves. During the first wave of an oil boom highly skilled workers are recruited to fill specialized positions within oil field companies. In the second wave, sectors such as construction that have experienced spin-off growth attract another set of skilled workers. During the third wave, less-skilled workers desperate for employment arrive based on rumour and expectations. Without job contracts or personal savings they often find themselves in need of support services, and are particularly vulnerable given that they are far away from the friends, family, and services that supported them in their home communities. While some of these workers end up finding decently paying jobs as general labourers, others settle for low-paying jobs in the many industries that service oil booms or suffer through periods of unemployment and homelessness.

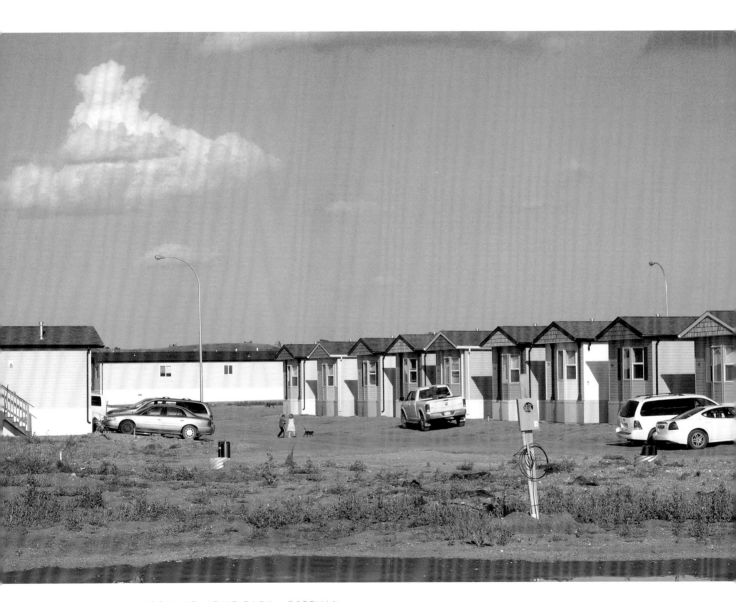

54. MODULAR HOME PARK - ESTEVAN

Canada's Temporary Foreign Worker (TFW) program delivers yet another category of worker to oil towns. Such workers leave their communities in the Ukraine, India, Mexico, the Philippines, and other marginalized areas of the world in order to enter Canada on temporary visas that bind them to a single employer. In Saskatchewan, these workers are increasingly recruited to fill low-paying positions in the accommodation and food services sectors; less than 1 percent work in oil extraction itself.[17] In fact, the number of temporary foreign workers in the accommodation and food services sector has climbed from just forty-five workers in 2005 to 2,300 workers in 2012.[18] The accommodation and food service sector now employs more temporary foreign workers than any other sector, with the construction industry employing the second largest number. The boom created enough of a demand for low-wage workers that businesses successfully persuaded government to grant thousands of temporary work permits in order to fill positions for which Canadian workers cannot be found.

In Saskatchewan's oil towns, temporary foreign workers are commonly found working in kitchens and serving at popular restaurants and bars, staffing fast food restaurants such as Dairy Queen and Tim Hortons, cleaning rooms at newly constructed hotels, and stocking grocery store shelves. As general labourers they can also be found working for oil field construction and service companies. In the city of Estevan I interviewed a number of temporary foreign workers, all grateful to have found work in Canada and all working towards acquiring permanent residency status—which has been made more difficult by recent changes to the TFW program. Most of these accommodation and food services workers made eleven dollars per hour, just one dollar more per hour than the provincial minimum wage. The more sought-after jobs include the opportunity to make tips, and the better employers secure decent housing for their staff. One worker identified a racialized hierarchy in her restaurant where Eastern European women are employed as wait staff while South and Southeast Asian men and women labour behind closed doors in the kitchen or occupy the position of "host," where they have less access to tips. Another worker told of a friend's difficult situation when the local Dairy Queen suffered a major fire and dozens of workers, tied through their visas to their single employer, were unable to work while it was being renovated and repaired. Despite such observations and experiences, the workers I spoke with reported being quite happy with their employment as a step toward longer-term goals that included higher-paying jobs in a variety of other fields.

55. OIL TANKS - RM OF OAKDALE

HOME
OF THE
1975
LEAPFROG
WORLD
CHAMPIONS
LAMPMAN TO REGINA
135 MILES 40 HOURS

56. CORRIGAN ROAD - LAMPMAN

57. RAINBOW MOTEL - SWIFT CURRENT

59. MALL - SWIFT CURRENT

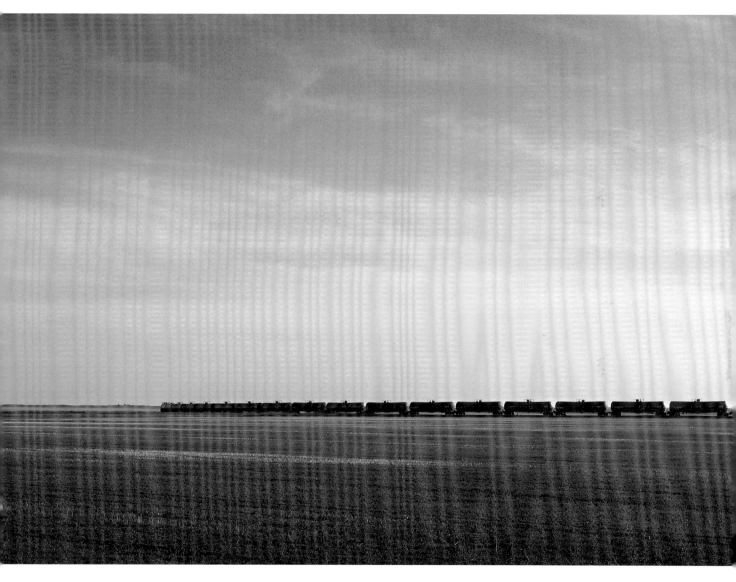

60. TANKER CARS - RM OF SNIPE LAKE

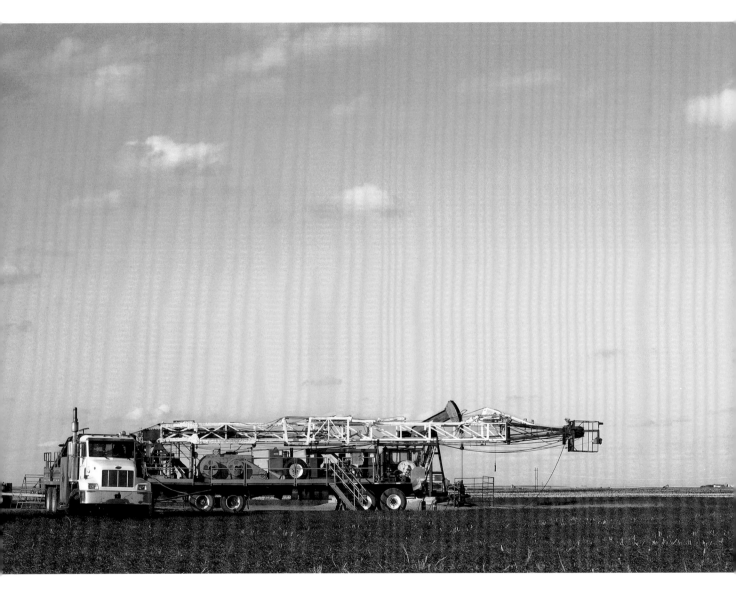

61. DRILLING RIG - RM OF SNIPE LAKE

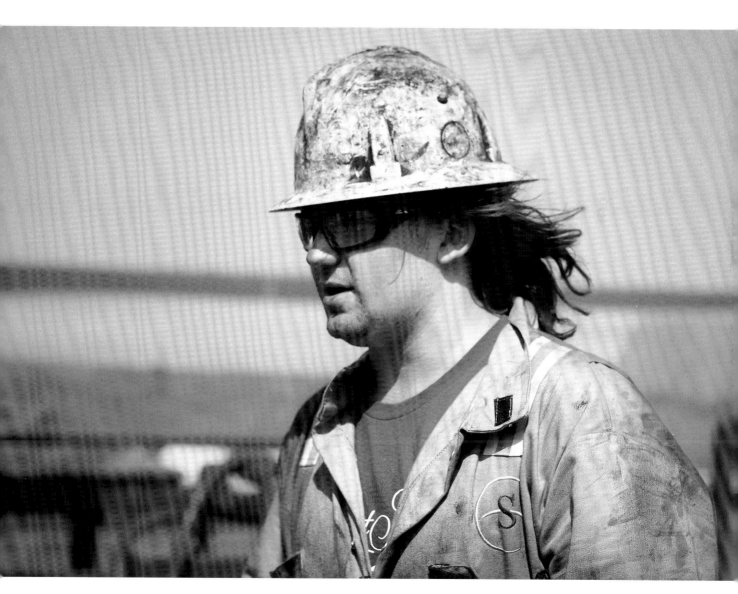

62. ROUGHNECK - RM OF ARLINGTON

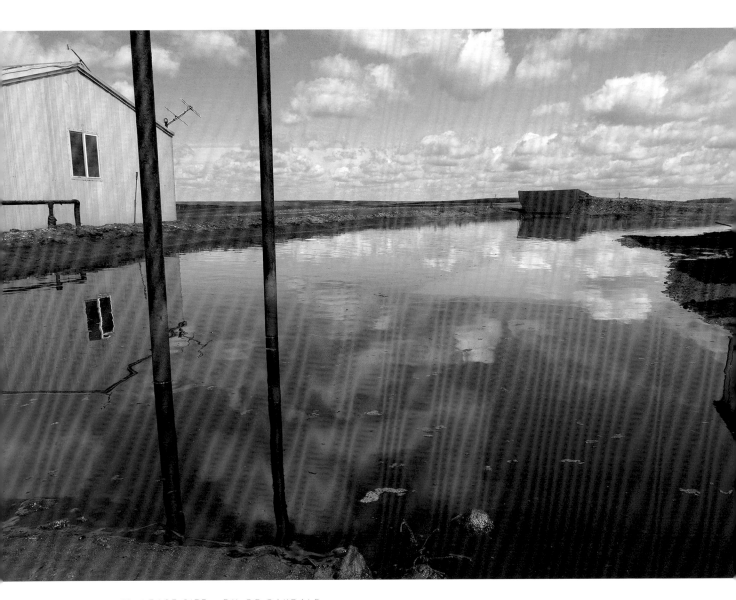

63. LEASE SITE - RM OF OAKDALE

Women are another group of workers that are overrepresented in the jobs that service the oil patch and its workers. Here again, the discrepancy between oil field wages and other work is significant. One effect of this pay gap is that the public and non-profit sectors have a hard time attracting and retaining workers. Yet, the services provided by these sectors are increasingly in demand. According to one psychologist in the southwest, the relatively low wages in non-oil field work has motivated women with partners in the oil field to exit the labour market in order to take care of children. The long and unusual hours of the oil field, combined with the high costs of child care (a going rate of $800 per child per month) has meant that women are incentivized to provide their own child care at home. This only exacerbates the problems of retention and recruitment in public and non-profit sectors, traditionally home to high numbers of female workers.

Perhaps the most difficult part of living in an oil town is securing housing. During periods of boom, housing prices are radically inflated and a dearth of housing supply results in vacancy rates reaching as low as 0 percent in some communities. Securing affordable housing under these conditions is particularly difficult for those making service industry wages, and especially for those without access to tips and without family members to contribute to a household income. For this reason, single low-waged workers often live in crowded conditions sharing a one-bedroom apartment. In one Saskatchewan example reported by the CBC, a franchisee of Tim Hortons forced six temporary foreign workers to share rudimentary accommodation in his friend's basement where they were each charged $500 to $600 per month.[19]

Those who can't find housing at all are forced to sleep in vehicles and parks, a practice that, while illegal, is tolerated by local police. In fact, one police chief told me that the police now consider it their duty to check on people sleeping in running vehicles as part of their beats: "We've been lenient on that...we may check on them to make sure they're alive, and wake them up, especially in the winter time when they're running [their vehicles], you want to make sure they haven't gassed themselves." During periods of bust, housing supply more closely matches demand, since many workers leave in search of new opportunities. In fact, in the spring of 2015, the vacancy rate in Estevan, the city referenced above with the high rental rates in 2014, rose to 20 percent.[20] This was certainly influenced by the bust in the oil patch, but was compounded by the end of a large construction project that had brought many temporary workers to the region to build carbon capture capacity on the city's coal-fired electricity plant.

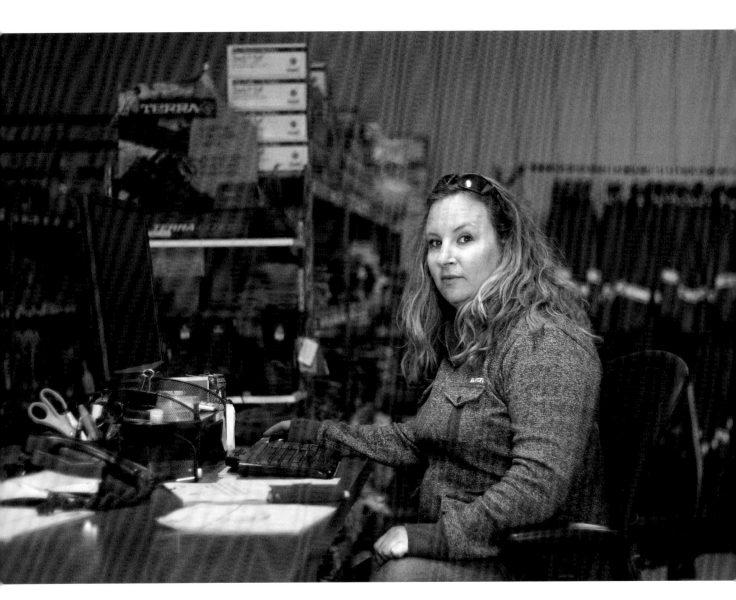

64. STEF · SHAUNAVON

The lack of housing in oil towns has, on the other hand, provided opportunities for local people to earn income by renting out rooms in their homes. In Estevan, the city council passed a number of incentives for both property developers and individual homeowners including tax abatements for newly built basement suites, incentives to develop apartments, and a new bylaw that allows for suites to be built over garages. One particularly eager farmer decided to build a motel in the middle of his barley field (photo 19). He commissioned fifteen custom-made shipping containers, each containing a bathroom, bedroom, and rudimentary cooking facility, and had them delivered to his field ten kilometres west of Estevan. In 2013 the CanStay Motel opened and operated without vacancy through the oil boom. Constructed from the technology that revolutionized the international shipping industry and made the global circulation of commodities faster and less labour-intensive, the CanStay is now home to a transient workforce that follows the vagaries of the boom-and-bust oil economy.

When I visited the CanStay Motel I was welcomed by the owner and several occupants preparing dinner outside on the barbecue. Teresa and Julian (photo 20) raved about the living conditions, despite the fact that they shared such tight quarters. Teresa enjoyed the sense of community that the occupants had developed. Although licensed as a motel, many of the occupants stayed for months on end and had no immediate plans to leave. They cooked together outdoors, stayed up around the bonfire after dark, and didn't have to worry about the "riff-raff" that had bothered them in Estevan. Their new landlords were thoughtful people who brought cold water and soda on hot days and genuinely cared about their renters. This was a great relief for the couple who had lived in their car for the first ten days after arriving in Estevan to work for an oil field construction and pipeline company. Desperate for housing, Teresa and Julian first secured a room at a local hotel where they paid $2,200 per month and the owners turned off the electricity and water at will. Julian commented that the hotel owners preferred to keep their clients in debt and that it took them several months to break free. Now, paying only $900 per month, the couple is able to start chipping away at debt they accrued before they found the oil patch.

Those non-resident workers not staying in hotels, shipping containers, or rooms in local residents' homes often find accommodation at man-camps. In the tiny town of Coleville, a small-scale, eighty-man camp was getting ready to open as I left town, and in Estevan, the ATCO camp had just closed down prior to my arrival (photo 33). A second camp housing 200 men was located outside of the

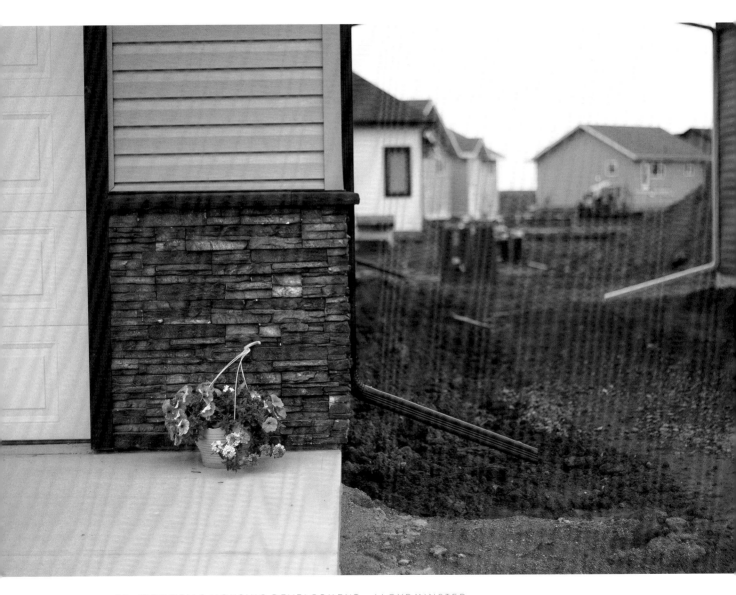

65. IRONWELLS HOUSING DEVELOPMENT - LLOYDMINSTER

city of Estevan, and served oil field and construction workers in town to build the $1.4 billion carbon capture project at the Boundary Dam power plant. Social service providers and faith leaders I interviewed were somewhat concerned about these camps, and especially about rumours that young women and school-aged girls were spending time at the camps at great personal risk. One faith leader was concerned that the camps, housing well-paid men away from or without families, have led to problems associated with alcohol and drug abuse and soliciting sex. According to a local police chief, alcohol and drugs are certainly a problem associated with the booming energy economy, but he noted that such problems are not on the scale of what is happening south of the border in North Dakota. Bar fights, drunk driving, and domestic disputes were of particular concern to the police chief, while soliciting was not. Moreover, the police chief was careful to point out that these concerns related as much to the locals as they did to "transient" workers.

Interviews with workers from mental health, addictions, and spousal abuse services confirmed that the booming oil economy has further stretched already tight resources in these areas of service. It is especially difficult for rural service providers to support the variety of mental health and addictions services that are needed by their clients, including both long-term residents and non-resident workers. One provider laments the inability of the local health region to provide continuity of care for clients coming from larger urban centres where they have started programs such as methadone treatment. In such cases, workers struggling through complex mental health and addictions issues, and unable to access the services they need, often experience setbacks. Moreover, the lack of available housing is cited by all social service organizations as exacerbating problems of mental health, addictions, and spousal abuse. Frontline workers spoke about women and children who stay in abusive relationships out of fear of becoming homeless. And one organization has been dealt a significant blow by the cancellation of its agreement with a local hotel to permanently reserve a room for victims fleeing abuse. Instead, the hotel opted to rent out the entire floor to an oil field company for whole seasons, meaning that unused rooms on any given night were now inaccessible to the agency.

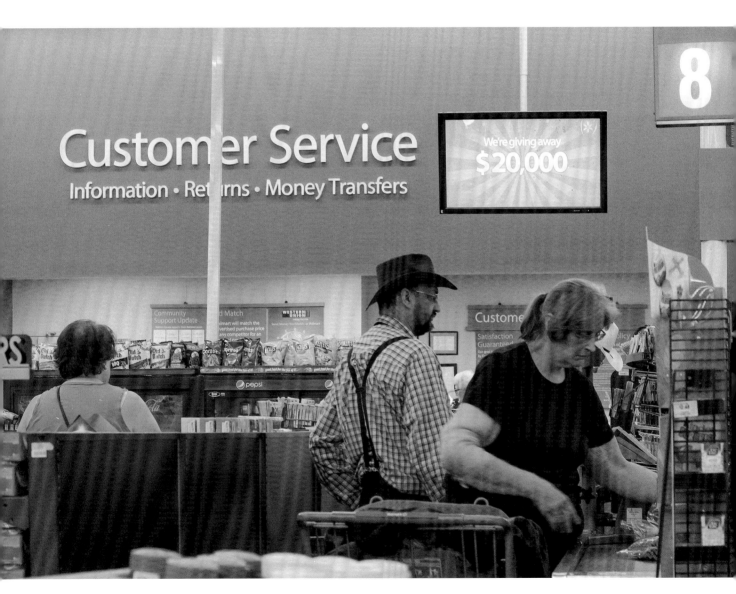

66. SUPERCENTRE - SWIFT CURRENT

67. STREET - ESTEVAN

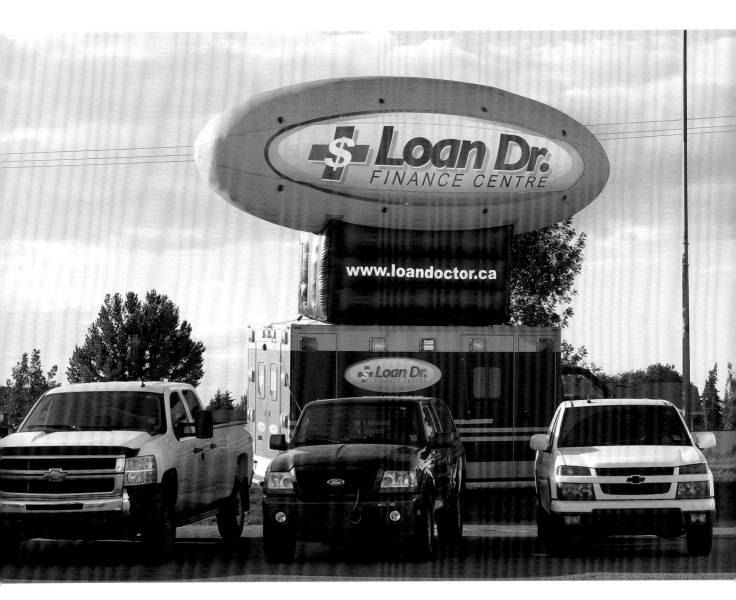

68. PARKING LOT - ESTEVAN

69. DUSK - RM OF BROCK

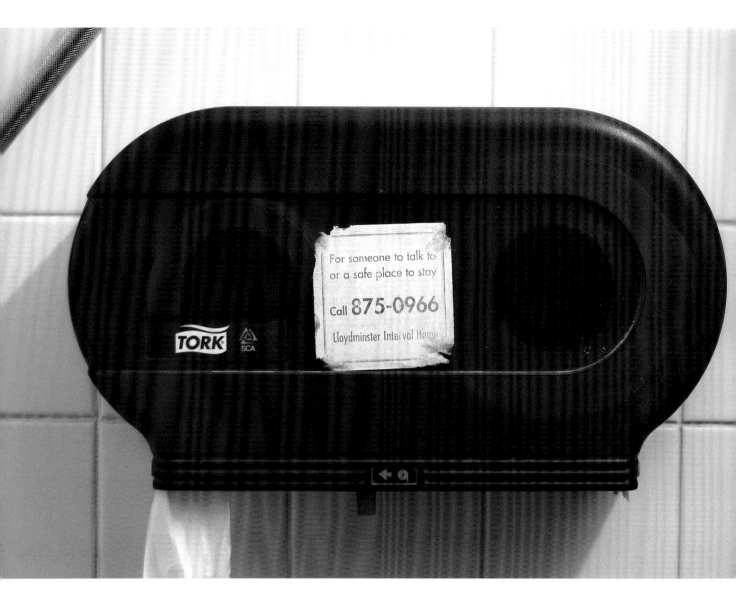

For someone to talk to
or a safe place to stay

Call **875-0966**

Lloydminster Interval Home

TORK

RESISTING THE OIL INDUSTRY

There is no organized movement against oil extraction in Saskatchewan. Even individual flashpoints of resistance are difficult to identify. Unlike the dramatic, concentrated impacts of Alberta's tar sands that social movements and Indigenous communities have been making visible to people across Canada and the world, the impacts associated with oil extraction in Saskatchewan are dispersed across vast geographies and largely being suffered in silence. In oil-dependent communities, criticism of the oil industry can translate into social isolation as those who speak too loudly are often deemed threatening to rural livelihoods. Where oil economies are understood as the last best hope for survival, the costs of speaking out are substantial. For these reasons, even the most small-scale eruptions of resistance warrant significant attention.

On 16 August 2013 the CBC and grassroots news organizations reported on one such eruption on Thunderchild First Nation (photo 35). Led by Marilyn Wapass and a small group of women, band members set up camp on their ceremonial Sundance grounds and vowed to defend the site from seismic testing already underway. In response, band officials sought and won a court injunction, which forced the land defenders to leave. But their twenty-one-day protest has, at least until now, stopped oil drilling on the sacred site, though slant drilling is happening nearby.

I visited Marilyn Wapass (photo 36) at Thunderchild Cree First Nation during the last day of the Sundance, just one year after the protest. Along with other members of the band and neighbouring communities, I watched Marilyn and the other Sundancers participate in ceremonies, and I stayed to take in the horse dance and the feast which conclude the Sundance. A circular lodge had been built out of aspen poles for the Sundance and bright colourful cloths, representing prayers, hung in trees and from the lodge. According to Marilyn, the Sundance is the most significant ceremony for many Indigenous cultures, and the grounds themselves are exceedingly sacred, in part because they host the lodges and prayer cloths of previous years. Until the mid-1900s the federal government prevented Indigenous peoples from engaging in Sundance ceremonies, and so

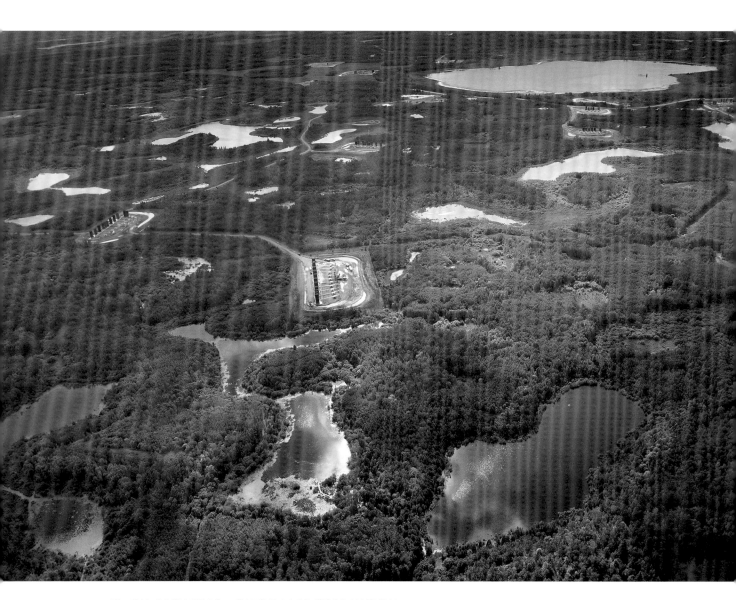

71. OIL FACILITIES - ONION LAKE CREE NATION

the Sundance is also bound up in relations of colonial domination and resistance.

Given this context, when seismic crews arrived shortly after the conclusion of the horse dance in 2013 and began carving out cutlines on the edges of the grounds, Marilyn decided to take a stand. In the process of preparing cutlines and setting off seismic explosions, prayer cloths that hung in trees had been torn down and desecrated; according to protocol, the lodges and cloths from previous years must not be removed from the site. In setting up camp on the grounds, the protestors were also making a statement that the chief and council had not conducted adequate consultation before they signed the exploratory permit. The protestors felt this was partly because the Thunderchild Cree First Nation stood to gain through their equity interest in Tonare Energy should the oil company proceed with extraction. While Marilyn's protest was supported by a small number of community members, she suggested that there is wider backing for her position in the community. However, few people are willing to take a public stance of opposition for fear of losing their employment, housing, or other necessities that are all distributed by the band.

While the costs of speaking out against the oil industry are grave in the rural settler communities of Saskatchewan, the repercussions are even more serious on reserves. As Marilyn suggested, band members feel that actions taken against band-sanctioned development puts them at risk of losing access to employment and social services controlled by band administration. However, there are few reserves located in the traditional oil-producing areas of Saskatchewan. For the most part, conventional oil fields coincided with agricultural production on lands that were cleared of Indigenous peoples through a policy of forced relocation, confinement, and starvation in the late 1800s. It is only recently that the industry has expanded into more remote locations and has sought access to more difficult-to-reach oil reserves by partnering with First Nations like Thunderchild.

Located just fifty kilometres north of Lloydminster and straddling the Alberta border, Onion Lake Cree Nation is one of the few reserves located adjacent to conventional oil fields and is the most significant oil-producing First Nation in the province. Since 2009, the First Nation has been producing heavy oil in partnership with two oil and gas companies and now has more than 400 producing wells. Production is concentrated on over 100,000 acres of land that the First Nation obtained through the treaty land entitlement (TLE) process starting in 1994. Significantly, on these TLE lands, Onion Lake acquired mineral ownership, so the band collects resource royalties on its production. On top

72. BUDDY'S PUB - ARCOLA

of joint ventures with production companies, the band has also developed oil field service companies, including water-hauling services, vac trucks, and service rigs. The band leadership's wholehearted embrace of oil development is celebrated by industry and advertised in a short video on the website of Aboriginal Affairs and Northern Development.[21]

While visiting Onion Lake I had the chance to speak with elders in the community who are concerned that oil development is changing traditional ways of life. For example, before oil development, band members used the current TLE lands for hunting and collecting berries and medicines. People now have to travel much farther to hunt and gather because animals largely avoid oil wells. According to elders, scarcely an animal track can be found in the TLE lands north of the reserve. Indeed, aerial photos (photo 71) of the muskegs of Onion Lake's TLE lands show distinctly dense development compared to the spacing of the oil wells outside of the reserve. For the elders I spoke with, this intense level of development is troubling because, as they explained, oil is to the earth like blood is to the body: it should not be sucked dry.

Leaving Onion Lake, I stumbled across a one-person protest. Charmaine Stick (photo 23) was sitting out in the rain under a brightly coloured umbrella at the reserve's main intersection. On day three of a hunger strike, she was protesting recent band elections that she believes were fraudulent. When I stopped to talk to her I discovered that her main concerns about the band and council revolve around what she perceives as an unfair distribution of the revenues from oil development, the large scale of the oil developments, and the lack of community consultation. Why are band members still living in substandard housing, she asked, when the reserve is pulling in revenues through its lucrative oil royalties? Like the elders, she emphasizes that the community has not been adequately consulted about whether they want the development and she worries about the effects the extraction is having on animals and the environment. While Charmaine received support from some community members for her protest, she has also experienced backlash from those in the community who support development. Charmaine worries that her protest might negatively impact her children's access to employment and band services.

A final example of resistance to oil extraction is ongoing on the highway that leads to Cenovus Energy's oil sands leases north of La Loche. On 22 November 2014, a group of Dene trappers set up a checkpoint on Highway 955 with the explicit purpose of keeping the uranium and oil and gas industries from further damaging trapping lines, animals, and the environment. Although the

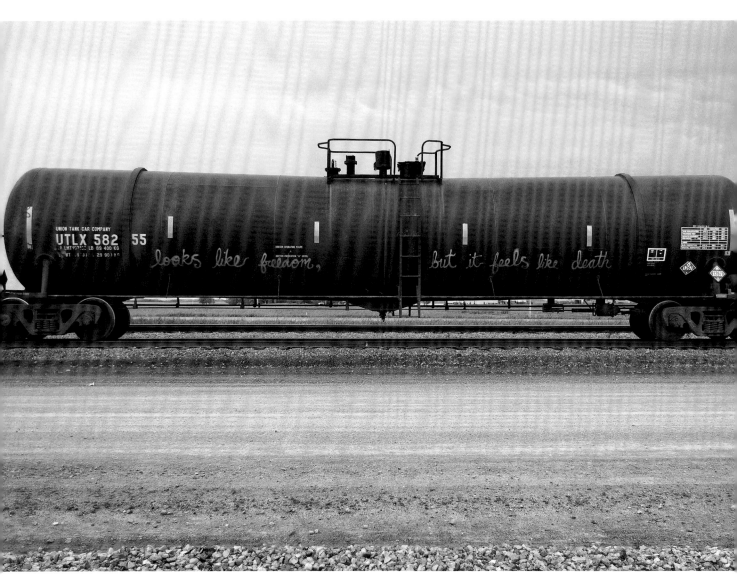

73. TRANSLOADING FACILITY - STOUGHTON

blockade was dismantled by the RCMP on 1 December, after the province sought and won an injunction, the Northern Trappers Alliance has maintained a camp and an information picket at the roadside and is demanding that industry leave the area. Long impacted by the uranium industry, the Trappers Alliance is desperate to keep Saskatchewan's tar sands in the ground. The greater depth and cost of production associated with Saskatchewan's oil sands has, until recently, kept them off of the industry's radar. Cenovus had planned to begin construction and development in 2014; however, plummeting oil prices temporarily forced a change in plans.

If Saskatchewan's oil sands are ever developed, they will be extracted through in situ wells, which will more closely resemble Alberta's use of steam-assisted gravity drainage (SAGD) than its large-scale mining projects. However, neither mining nor SAGD are appropriate for Saskatchewan's sands, which are too deep to be mined, yet too shallow for SAGD. While the surface impact of in situ production is much reduced compared to open-pit mining, if Saskatchewan's extraction technology uses a modified version of SAGD it will require large amounts of fresh water and an energy source to produce large quantities of steam. Residents fear that rumours about the possibility of a small nuclear reactor to fuel tar sands

developments in both Saskatchewan and Alberta might come true. After all, the provincial government has already floated the idea, although the public backlash, drawing on the long history of Saskatchewan's anti-nuke movement, was furious. In a Facebook group devoted to the struggle of the Northern Trappers Alliance, members refer to their territories as sacrifice zones.

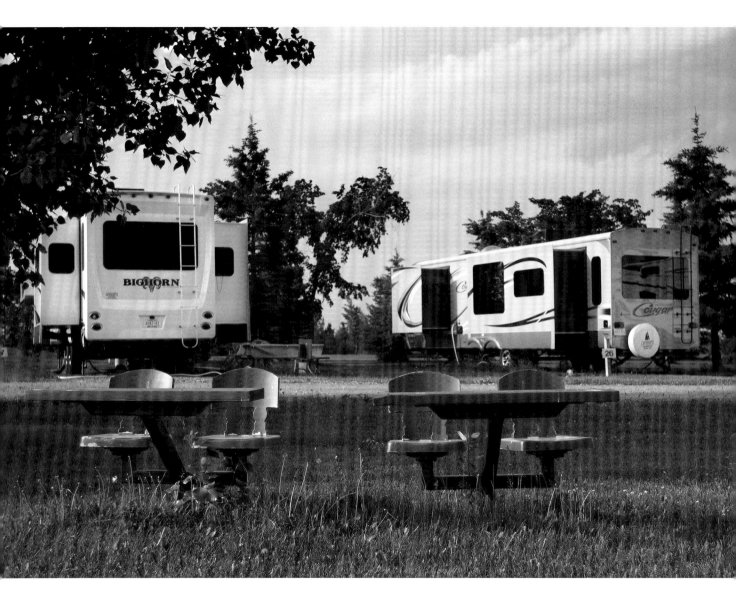

74. ROLLING GREEN RV PARK - LLOYDMINSTER

75. DEREK - STOUGHTON

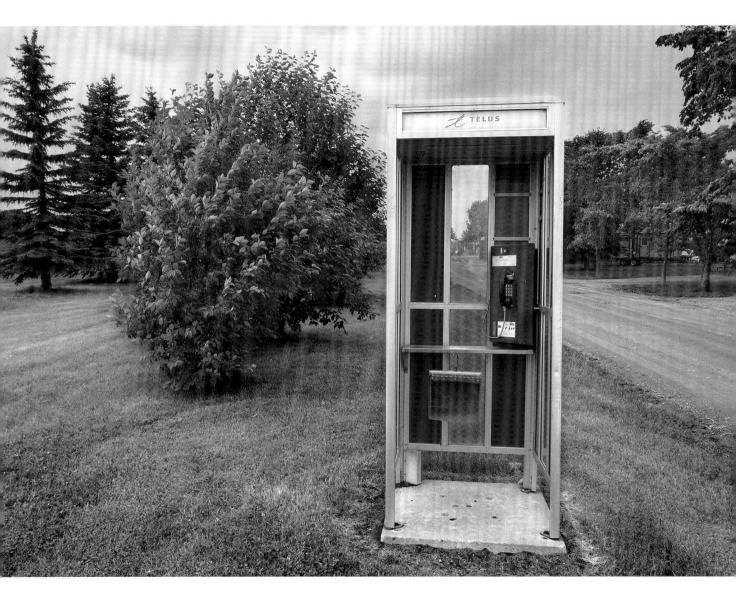

76. PHONE BOOTH - LLOYDMINSTER

CONCLUSION

In a province that has long considered itself Alberta's poor cousin, enthusiasm for oil extraction during the recent economic boom was palpable. No longer a recipient of federal transfer payments, the province boasts that the economic tides have turned and that people are returning home to forge a life and livelihood in the cities and rural communities of Saskatchewan. The oil economy has been an important factor in this sense of provincial renewal, and many people in oil-producing regions are truly thankful for its contribution to this economic revival.

Conversations about the impacts of extraction are, however, surprisingly absent from the public discourse about oil extraction. This is not because rural and Indigenous communities are unaffected. Rather, it is because of the fragility and complexity of residents' relationships with industry. For the hosts of oil infrastructure, complaints that call into question the legitimacy and desirability of the industry can lead to blowback from community members and leadership. In this context, it is much more realistic to fight for better compensation from oil companies through organizations like surface rights groups than to risk alienation for pointing to environmental and health impacts or the loss of traditional livelihood practices such as hunting and collecting medicines and berries. For those servicing the boom, the profound relationship of inequality between oil field and non–oil field work is willfully overlooked because such jobs would disappear without a thriving industry. As this book illustrates, people are not unaware of or unaffected by oil's impacts: alternative economies and sources of employment are hard to come by.

The global crash in oil prices over the winter of 2014–15 has thrust the future of Saskatchewan's oil economy into a period of uncertainty. Oil field service companies like Halliburton have already announced that they are closing down operations in the province, drilling has slowed down dramatically, and the reduction in oil royalties has strained government coffers. It is unclear for how long oil prices will stay low. Oil giants like Saudi Arabia are currently flooding the international market in order to drive many costly, unconventional operations in North America and elsewhere out of business. It is yet too soon to tell whether the next uptick in world prices will bring unconventional fields back online. Regardless, without a drastic change in course, oil-producing communities are destined to continue their precarious positions in

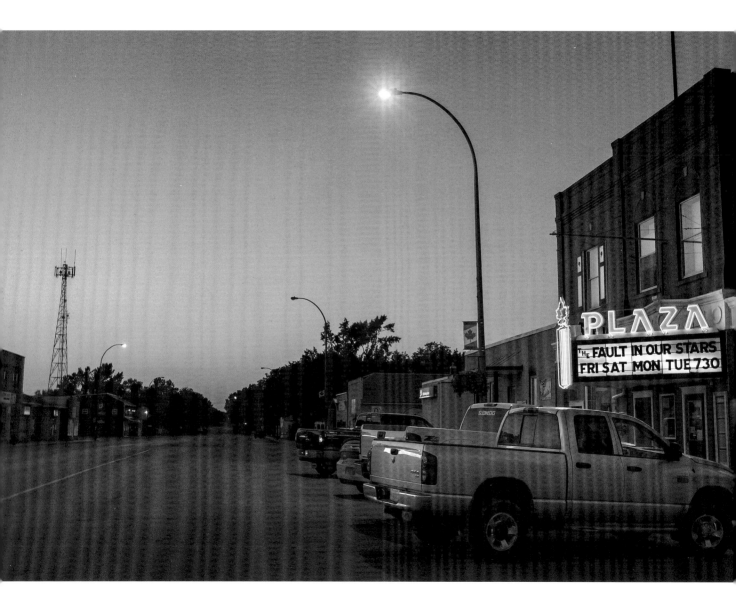

cycles of boom and bust. Contemporary booms and busts are, however, playing out within broader forces that are making family farms more precarious, weather more unpredictable, and rural and Indigenous spaces more subject to the vagaries of international financial flows and markets. Arguably, much of the social and economic infrastructure that rural families counted on during times of hardship has been stripped away.

The recent downturn, although certainly painful for oil-producing regions, also opens up opportunities to articulate a different future. The burden is on us all to bring to life alternatives that can break the cycle of boom and bust and that are more environmentally and socially just. In so doing, we ought to defend people's rights to livelihood, and their choices to stay in the communities that they call home and on the lands that they have stewarded for generations.

NOTES

1 Roy Schaeffer, "In the Public Interest: The Oil and Gas Industry of Saskatchewan, 1905–1950" (MA thesis, University of Saskatchewan, 1988), 14.

2 Letter from Thomas Douglas to B.F. Lundy, 21 March 1949, cited in John Richards and Larry Pratt, *Prairie Capitalism: Power and Influence in the New West* (Toronto: McClelland and Stewart, 1979), 136.

3 Richards and Pratt, *Prairie Capitalism*, 177.

4 John W. Warnock, "Remembering Sask Oil, It Can Be Done!" *The Bullet E-Bulletin* 672 (31 July 2012), http://www.socialistproject.ca/bullet/672.php.

5 Ibid.

6 Ibid.

7 Richards and Pratt, *Prairie Capitalism*.

8 Warnock, "Remembering Sask Oil."

9 Lisa Fattori, "Staying the Course in 2012: Saskatchewan's Oil Industry on Track for Continued Growth," *Saskatchewan Oil Report,* 29 January 2013, http://saskatchewanoilreport.com/staying-the-course-in-2012-saskatchewans-oil-industry-on-track-for-continued-growth/.

10 Melinda Yurkowski, "Saskatchewan Oil and Gas Update," 2014, http://www.ndoil.org/image/cache/Melinda_Yurkowski.pdf.

11 Melinda Yurkowski, "Saskatchewan Oil and Gas Update," 2013, http://wbpc.ca/pub/documents/archived-talks/2013/Yurkowski%20Saskatchewan%20Updates%202013.pdf.

12 Ibid.

13 Geoff Leo, "Sour Gas from Oil Wells a Deadly Problem in Southeast Saskatchewan," CBC News Saskatchewan, 21 April 2015, http://www.cbc.ca/news/canada/saskatchewan/sour-gas-from-oil-wells-a-deadly-problem-in-southeast-saskatchewan-1.3042939.

14 Ibid.

15 Enform, "Quarterly Accident/Injury Stats," http://www.enform.ca/enform_sk/Quarterly-Accident-Injury-Stats.aspx (accessed 23 February 2015).

16 Adriana Christianson, "Estevan Rental Rates Higher than Vancouver, Calgary or Toronto," *CKOM,* 12 June 2014, http://ckom.com/article/192325/estevan-rental-rates-higher-vancouver-calgary-or-toronto.

17 Andrew Stevens, "Temporary Foreign Workers in Saskatchewan's 'Booming' Economy" (Regina: Canadian Centre for Policy Alternatives, 2014), 8.

18 Ibid.

19 Fabiola Carletti and Janet Davison, "Who's Looking Out for Tim Hortons' Temporary Foreign Workers?" CBC Hamilton, 12 December 2012, http://www.cbc.ca/news/canada/hamilton/news/who-s-looking-out-for-tim-hortons-temporary-foreign-workers-1.1282019.

20 Will Chabun, "Despite Weak Oilpatch Boosting Vacancy Rate, Rent Continues to Rise: CMHC," *Regina Leader-Post,* 14 June 2015, http://www.leaderpost.com/business/Despite+weak+oilpatch+boosting+vacancy+rate+rent+continues+rise+CMHC/11137588/story.html.

21 Aboriginal Affairs and Northern Development Canada, "Investing in the Future – The Onion Lake Cree Nation Story," 2013, https://www.aadnc-aandc.gc.ca/eng/1377775603370/1377775783343.

The text of this book is set in Garamond Premier Pro, 11/13.
The title text is set in Gotham HTF and Brandon Grotesque.

The book was printed in 200 line-screen
on 100 lb. Garda Art Silk Text.

Printed by Friesens.